PATRICK CAULFIELD

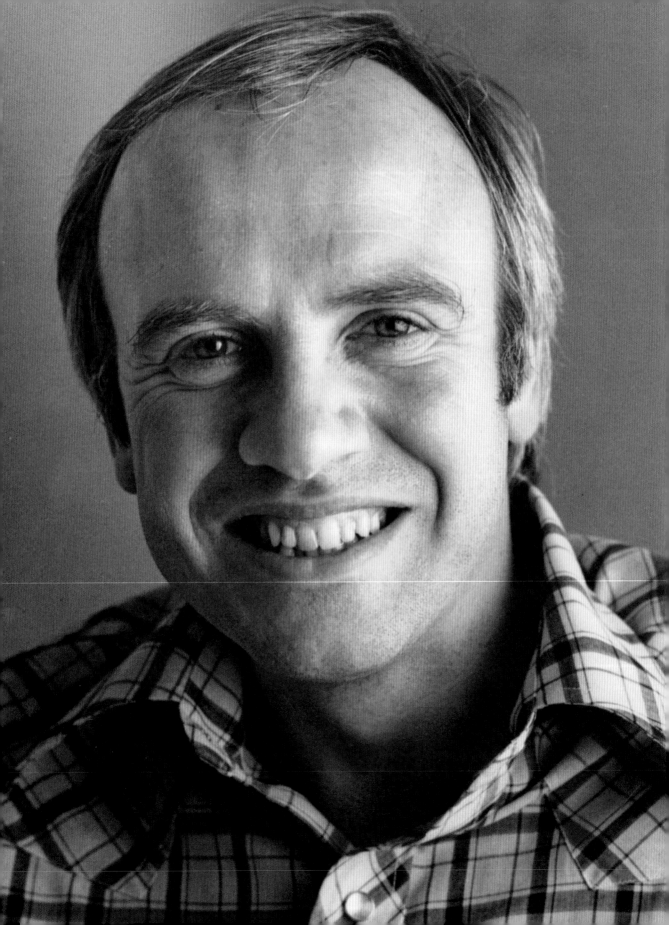

PATRICK CAULFIELD

BRITISH ARTISTS

CLARRIE WALLIS

TATE PUBLISHING

First published 2013 by order of the Tate Trustees
by Tate Publishing, a division of Tate Enterprises Ltd,
Millbank, London SW1P 4RG
www.tate.org.uk/publishing

On the occasion of *Patrick Caulfield*
Tate Britain, 5 June – 1 September

A catalogue record for this book is available from the British Library.
ISBN 978 1 84976 127 7

Distributed in the United States and Canada by ABRAMS, New York
Library of Congress control number applied for

Designed by Webb & Webb

Colour reproduction by DL Imaging Ltd, London

Printed in China by Prosperous Printing

Front cover: Patrick Caulfield, *Selected Grapes* 1981 (see fig.52)
Frontispiece: Michael Newton, Portrait of Patrick Caulfield for
Connoisseur interview, October 1981

Measurements of artworks are given in centimetres, height before width.

For Felix and Luke

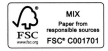

CONTENTS

1
Self-portrait
1951
Pencil on paper
22 x 22
Collection Peter Ward

1 FACING THE FUTURE

PATRICK CAULFIELD (1936–2005) is known for his iconic and vibrant paintings of modern life which reinvigorated traditional subject matter such as landscape, interiors and the still life. His work came to prominence in the mid-1960s after he studied at the Royal College of Art where his fellow students included David Hockney. Through his participation in *Young Contemporaries* in 1961 and 1962 and the defining *The New Generation* exhibition at the Whitechapel Art Gallery in 1964, Caulfield became associated with pop art. Caulfield himself resisted this label throughout his career, instead preferring to see himself as a 'formal artist' and an inheritor of European painting traditions from modern masters such as Georges Braque, Juan Gris and Fernand Léger, who influenced his composition and choice of subject matter. Although Caulfield's paintings can appear straightforward, this is deceptive and hides the sophistication with which he brings together different pictorial languages. By his own admission there were periods when he sought simplicity and others when he sought complexity; his evolution as an artist is not a simple narrative. As he explained in 1998:

> I don't think that my painting has moved in a straight line, formally, or progressed evenly. At different periods, I have done simple things. Then I've complicated everything, and then gone on to another kind of simplification

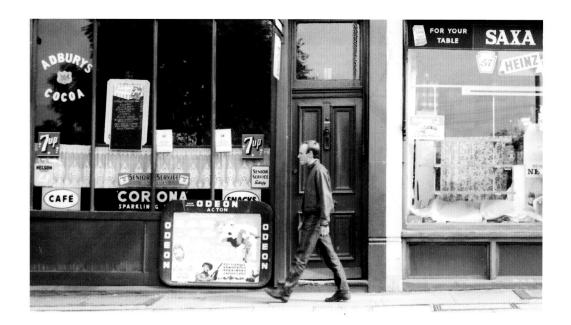

again – as most artists do. It's not a fixed development. A simple description
of the way that I've worked is to say that having painted and drawn in a
linear way, without shadow, I gradually abandoned the linear structure
and began to rely much more on light and shade which is perhaps a more
sculptural interpretation of my visual world.[1]

2

Patrick Caulfield, Horn
Lane, Acton, 1961
Photograph by Peter Ward

Caulfield was born in the working class area of Acton, west London in 1936.
(fig.2) His parents, of Irish Catholic descent, were both originally from
Bolton, Lancashire and in his youth his father had been a coal miner. The
family returned there to live prior to the outbreak of the Second World War.
'We were living in one of those classic, Victorian terrace houses, a solid row,
where everybody did their doorstep with red polish. The milk sometimes
came on a horse and cart in a churn. Outside lavatory, no bathroom. I was
brought up in something that only exists in the history books, now.'[2]

While Caulfield had a happy childhood with one older brother, he never
forgot his modest background and the bleak aspects of his impoverished
surroundings. When talking of his childhood, Caulfield conveys a sense of a
certain emptiness caused by a rather stilted emotional life that in retrospect
lacked the material goods and cultural richness that his paintings later went on

to depict. The family, Caulfield remembered, 'had relations but no friends' and was not communicative, rarely speaking: 'Not even "Pass the peas" because my mother would cook a meal and serve it all on the plate so we never spoke to each other and nothing personal, or emotional.' In a telling snapshot of his young life he told how 'for entertainment, we used to collect car numbers, but we used to have to walk to the main road because there were so few cars.'[3] During the War his father worked at the de Havilland Aircraft Company factory and his mother an ammunitions factory. At the end of the war the family moved back to Acton, home to heavy industry and known as Soapsud Island because of the large number of laundries. Caulfield and his family lived in accommodation above a cobbler's shop at 224 Horn Lane which overlooked the main railway line from Paddington to the West Country. This was, above all, a holiday line and in later life Caulfield remembered how he liked to look longingly through the carriage windows at couples dining together in the buffet carriage of the Cornish Riviera Express train being transported to Penzance and the beaches of St Ives.[4]

Caulfield attended Acton Central Secondary Modern School. It was a fairly limited school that aimed to produce office workers and so offered shorthand and typing lessons to the older children. His school year was only the second in which a few of the children, including Caulfield, were allowed to stay on for an extra year and sit O-level exams at fifteen. As a child Caulfield excelled at Art and was also good at writing imaginative essays. One of Caulfield's earliest known works is a small self-portrait in the kitchen of his home dated 1951 (fig.1). Made when he was fifteen years old it is a finely executed line drawing of his head and shoulders with a pendant lamp dangling above. To the left on the wall there is a small watercolour of a sailing barge which he had painted the year before, and there is the hint of a doorframe which helps define the room. In his spare time he enjoyed creating models and developed a taste for devising stage sets for plays, writing skits or inventing amusing parodies of events. Throughout his life Caulfield was known for his shyness and yet he also enjoyed dressing up and as an adult he still retained a love for fancy dress parties. For one school sports day he dressed up as he imagined a public school boy would dress for such an event based on Edwardian illustrations. He also had a love of military insignia and history, especially the Franco-Prussian war, and board games. Peter Ward, a close childhood friend recalls, 'From his school days and for many years Patrick's interest was always captured by the challenge of creating a pastiche or replica. We built a shooting gallery, a model theatre with scenery, model layouts for war gaming and once

he carved out of a large bar of white soap a Greek horse's head which was stunningly life like. Later we recorded fake radio dramas, films and pastiche film posters and pantomimes.'[5]

In the 1950s, the self-image of post-war Britain was one of common self-sacrifice, of a nation which had pulled itself together in a moral crusade against fascism. After the defeat of Germany and Japan there was an expectation that this sense of social cohesion would continue and that a return to the rigid class structure of the pre-war years was both impossible and undesirable. The 1944 Education Act instituted State provision of secondary education to all, with the creation of grammar schools and secondary moderns. This helped provide the foundation for an increased social mobility that was to characterise the 1960s. The General Election of 1945 was a resounding victory for the Labour Party. Widespread nationalisation of the coal mining industry, the utilities and railways was accompanied by the formation of the National Health Service. In the words of the Labour manifesto, *Let Us Face the Future*, the aim was to produce a nation that was 'freely democratic, efficient, progressive, public-spirited.' These are the keywords of this period, capturing the high hopes and expectations of radical change. Despite this desire for change the economy was still weak from the war effort. Until 1948 the most basic foodstuffs were rationed along with clothing, chocolate and fruit and while rationing eased in 1950 it was not until 1954 that it finally ended. In 1951 a Conservative government returned to power but there could be no return to the earlier status quo. The world economy was recovering from the war years and British industry was growing rapidly as a consequence. Growth led to a demand for workers at all levels and aided social mobility with the class divide between shop-floor and management becoming less of a barrier. Between 1950 and 1960 wages increased by 25% while prices increased much more slowly and with greater disposable income people from all classes began to expect a standard of living that only the wealthier could have had before the war. America was an icon of a culture of plenty. Housing, cars, TVs and consumer white goods became a realistic expectation for the majority aiding the birth of modern consumerism. The Festival of Britain in 1951 foreshadowed these changes. If the rhetoric was of a new Elizabethan era it was, the Festival suggested, one that was ready to ditch the backward looking 'tudorbethan' style for something that was modern and for all.

Against this background Caulfield left school at the age of fifteen. At his last prizegiving he won the art prize which was a book about the French painter

3
**Greece Expiring on the
Ruins of Missolonghi
(after Delacroix)**
1963
Oil on board
152.4 x 121.9
Tate. Purchased 1980

Eugène Delacroix. Ten years later, in his final year at the Royal College of
Art, when given the assignment to make a transcription of a famous painting,
he chose Delacroix's *Greece Expiring on the Ruins of Missolonghi* 1827.
The painting focuses on a woman in traditional dress, representing Greece.
Her arms are raised in a gesture of helplessness as she surveys the scene of
the mass suicide of the patriots who chose death rather than surrender to
the Turks. The painting commemorates the people of Missolonghi and is
symbolic of freedom against tyrannical rule. Caulfield deliberately chose
to work from a black and white reproduction of the Delacroix painting so
that the colours would be left to his imagination and in his painting *Greece
Expiring on the Ruins of Missolonghi (after Delacroix)* 1963 (fig.3) he used
a limited range of household gloss paints, substituting flat areas of colour and
a hard-edged style for Delacroix's more emotive brushstrokes.

Caulfield's first job after leaving school was working in a factory on the
Park Royal Industrial Estate in west London. He then worked for Crosse
& Blackwell in Soho Square, first as a filing clerk and then in the design
department. One task was to varnish chocolates for display. It gave him a
lasting love for Frank Dickens's cartoon character Bristow, serialised in the
Evening Standard – a bowler-hatted 'ineffectual rebel' who works as a buying

clerk in an office. Caulfield would pass the time with Bristow-like pranks like flicking rubber bands at pigeons on the office window ledge.[6] In later years Caulfield said that he shared Dickens's attitude to 'ordinary' life. 'He embraces it in a rather affectionate way, but it is also very alien. And I suppose I found in Dickens's cartoons an echo of the way I felt when I was working on the filing cabinets at Crosse & Blackwell. I feel there's something quite heroic about office workers, in a way. Keeping that sort of scepticism going.'[7]

During this period he became an enthusiastic jazz fan and, as Peter Ward describes, 'We roamed London searching out weird and atmospheric pubs. Our usual haunt was Thames side pubs in Hammersmith and … Jazz pubs such as Eel Pie Hotel on Eel Pie Island and The Green Man at Twickenham.'[8] Jazz was relatively new to Britain and had the allure of otherness and was part of an expanding sense of possibility, an 'everyday exotic', that his paintings went on to explore. The sense of affection coupled with a feeling of detachment that he speaks about in relation to Dickens's cartoons would also later be reflected in his work. Like many working class men and women who benefited from the rapidly changing post-war world, Caulfield may have found it difficult to shed a sense of being something of an outsider to the middle class milieu; the world of office worker was new enough to be seen as heroic.

In an interview with Lynn Barber at the time of his Hayward Gallery retrospective in 1999 he was asked if he was mocking the restaurants in his paintings and he replied that he was simply recording them. 'They're not things I disparage. They're just, merely history really. Recent history. Like, if you wanted to have an image of Italy, there's a particular white plastic moulded chair … you find them in France as well, but somehow I think of Italy … That wouldn't be a criticism, it would just be a fact.'[9] Barber sees Caulfield's paintings as reflecting the heroism of modest human hopes and aspirations which express affection for lost dreams. They touch upon issues about taste and class, things doubtless forged in these early years.

In 1953, pre-empting call up for National Service he enlisted for three years with the Royal Air Force and was posted to Coastal Command HQ, Northwood, Middlesex, where along with the actor Richard Briers he worked as a filing clerk. Inspired by John Huston's film *Moulin Rouge* about the artist Toulouse-Lautrec, Caulfield attended evening classes at Harrow School of Art. Two nights a week he studied life drawing and portrait painting with a view to applying for art school. 'It was the first time I had

drawn from a model, and I felt very strange in my hairy uniform drawing from this Michelin-type woman', he remembered.[10] Caulfield accepted the offer of a place at Chelsea School of Art, beginning in September 1956. He moved into a bedsit in the Royal Borough of Kensington and Chelsea and so was eligible for a local authority grant. This, together with savings from his RAF pay, enabled him to be financially secure. In the first term he studied Graphic Design before transferring to the painting department where his tutors included Jack Smith and Prunella Clough. Caulfield also benefited from the guidance of the principal, Lawrence Gowing, who created an egalitarian atmosphere in which he thrived.[11]

The impact of cookery writer Elizabeth David exemplifies the cultural sea-change of the 1950s. In 1949 David began publishing articles on Mediterranean cooking for *Harper's Bazaar*. These caused a stir and in 1950 she collected the articles and published them in *A Book of Mediterranean Food*. The publisher was John Lehmann, noted more for publishing poetry than cookery and the book also featured lengthy quotes from writers such as D.H. Lawrence, Gertrude Stein and Lawrence Durrell, and was illustrated by John Minton. It was a sensation. Reactions at the time reflect the author's own 'agonised craving for the sun' as the long years of wartime deprivation extended into post-war austerity. Contemporary reviews also capture this sense of another possible world: a world of aesthetic pleasure that the book's literary, culinary and visual components echoed. For example, Cyril Connolly, the literary critic and writer, wrote of France offering the artist or writer 'the Mediterranean for a sun-lamp and Paris as his oxygen-tent.'[12] This exemplifies a particular sense of the exotic that Caulfield was to react to.

In most surveys of the 1960s, this decade is identified as beginning not in 1960 but rather 1956, which was also the year that Caulfield started at art school. The historical developments of this decade are best set within the broader framework of Cold War politics – the Suez Crisis and the Hungarian Uprising – a time when governments were desperate to cement the fragile political reconstruction of Europe. That Paris was no longer considered as the centre of the visual arts had started to become a common observation – perhaps to be replaced by New York. It was the year that the Kitchen Sink realists like John Bratby represented Britain at the 1956 Venice Biennale. 'Kitchen Sink' was a term coined by the influential art critic David Sylvester, for a group of painters who found

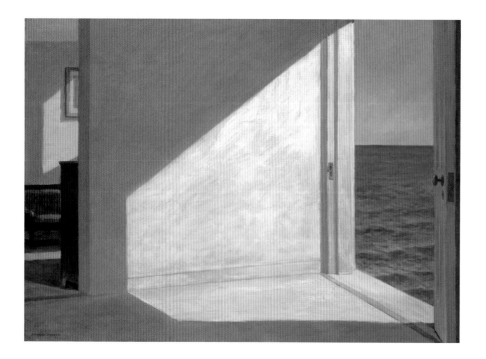

inspiration in urban spaces.[13] Their work celebrated the everyday life of ordinary people implying a social if not political interest. One of the group – Jack Smith – won first prize at the John Moores exhibition in Liverpool with his *Creation and Crucifixion*. It was also the year that the exhibition *Modern Art in the United States*, a survey of twentieth-century American art, was held at the Tate Gallery, featuring works from the collection of the Museum of Modern Art, New York. This included the work of Willem de Kooning, Robert Motherwell, Jackson Pollock and Mark Rothko amongst others. While Pollock's work had been seen in the exhibition *Opposing Forces* at the ICA in 1953, it was Britain's first major exposure to the vitality of modern American art. Not since Roger Fry's two post-impressionist exhibitions of 1910 and 1912 had the British art world been so divided. The final room, which displayed twenty-eight abstract expressionist paintings, had an enormous impact on the work of many British artists, including Peter Lanyon, Terry Frost, Roger Hilton and Patrick Heron, who wrote about his excitement at 'the size, energy, originality, economy and inventive daring of many of the paintings.'[14] While Caulfield produced a few paintings that were inspired by Philip Guston (1913–80), who was also included in the exhibition, it was the work of Edward Hopper (1882–1967) and Stuart Davis (1892–1964) that

4
Edward Hopper
Rooms by the Sea
1951
Oil on canvas
74.3 x 101.6
Yale University Art Gallery.
Bequest of Stephen
Carlton Clark, B.A. 1903

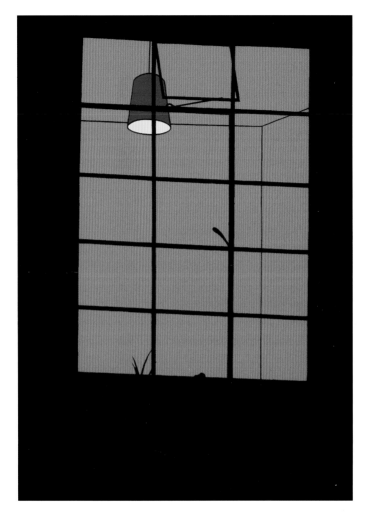

5
Window at Night
1969
Oil on canvas
213.4 x 152.4
Private collection,
London

grabbed his attention. He thought that 'the contrast between meticulous realism and bold abstraction was intriguing.'[15]

Caulfield was particularly drawn to Hopper's carefully rendered depictions of interior and exterior views of everyday surroundings as characterised by his painting *Rooms by the Sea* 1951 (fig.4), one of three works included in the exhibition. Hopper's *Rooms by the Sea* depicts a hallway with a room visible on the left; through the open front door to the right we can see the ocean. The room is barely glimpsed – it is the flat, unornamented hallway wall that dominates the centre of the picture. Slanting from the doorway is a rhombus of sunlight that creates a stark geometrical form in its own right; this is echoed by a similar, smaller, patch of light on the wall of the room, from an unseen

window. The colour palette of the interior is muted; that of the ocean much
more vivid. Nature seems to be entering the drab space of the human interior.
Curiously the water seems to lap right up to the doorstep and the proximity of
the sea is menacing. Where one would expect dry land, an expanse of water has
replaced it, as if at any moment the house could be invaded not just by sunlight
but by the destructive weight of the waters.[16] The picture has a haunting
quality that is reminiscent of Giorgio de Chirico's metaphysical paintings
where a timeless moment is depicted, suspended between past and future.

Caulfield was impressed by Hopper's handling of two-dimensional space,
his treatment of light and shade and the frozen time quality of his interiors.[17]
Hopper had an intellectual yet individualistic approach to painting, in which
he incorporated *mise en scènes* into a chosen typology of interiors, exteriors
and landscapes. In retrospect, comparisons can usefully be drawn between
Caulfield's approach to subject matter and composition and that of Hopper.
Both artists painted imaginary things that did not refer to specific places
but rather were 'types' of places that nonetheless reflected their own sense
of the times in which they lived. Committed to finding a way to picture
modern life, Hopper was attracted to American motels and diners, places
through which people passed rather than the homes where they live, whereas
Caulfield's interest developed from self-consciously exotic and romantic
themes such as views of ruins and the Mediterranean, and to café interiors,
foyers and restaurants. While Hopper's paintings are closer to theatrical
tableaux, both artists revelled in the mysteries of the charged non-event,
evoking preludes or aftermaths, moments when things are about to happen
or have just happened. This is particularly true of Caulfield's paintings of
the 1970s onwards, for example, *Paradise Bar* 1974 (fig.43) in which the
precise disposition of only a few identifiable elements creates a vivid sense
of time and place. Like Hopper, Caulfield used abstract forms of light as
key compositional elements in conjuring up a sense of architectural space.
For Caulfield light was an animating force, giving form and space but also
revealing the poetry inherent within any situation. His depiction of light is
not a direct representation but reflects the artist's thinking about how it can
be used to create a mood or feeling. The unyielding brightness of artificial
light in *Window at Night* 1969 (fig.5), where the viewer looks through a
window into a room illuminated by one overhead lamp, or *Café Interior:
Afternoon* 1973, where a strong diagonal blue and black line suggests late
afternoon shadows raking across the imaginary space, demonstrate this
creation of atmosphere through the use of light. Elsewhere, in paintings such

6
Stuart Davis
Egg Beater No.4
1928
Oil on canvas
68.9 x 97
The Phillips Collection,
Washington DC

as *Red and White Still Life* 1964, light is registered as geometric forms such as rhomboids or parallelograms, evoking a sense of natural light coming in through a window or door which is often just beyond the picture plane.

Caulfield was also struck by the work of Davis, an artist who painted modern American subjects in a vibrant style loosely derived from the Synthetic Cubism of Pablo Picasso (1881–1973) and Georges Braque (1882–1963). In the early 1920s paintings such as the so-called *Tobacco Still Lives* employed motifs from cigarette packets and labels in which overlapping shapes highlighted the influence of cubist collage. Later in the same decade he moved closer to abstraction with paintings such as the *Egg Beater* series (fig.6), in which he reworked a still life from a kitchen table with bright colours that recalled Léger's geometric forms. Davis deliberately chose unrelated objects – eggbeater, electric fan, and rubber glove – so that he could concentrate on the relationships between colour, shape and space. He spoke of visualising these elements in relation to each other, within a larger system that unified them in the space and on the picture plane. Davis's paintings matured into works that celebrated the urban environment. His perception of the modern world was influenced by an interest in jazz music, the incorporation of imagery from commercial packaging and advertising,

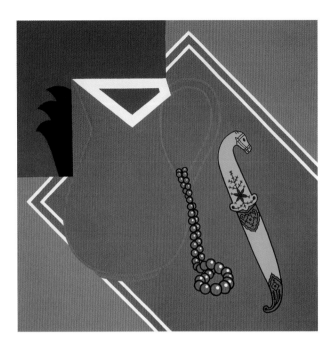

and his wit, all of which was conveyed by the titling of the paintings. His paintings from the 1930s reflect his fascination with the particularities of the New York streetscape – from the shop signs, gas pumps, decorative ironwork, to fire escapes, awnings and the changing skyline. Davis's work may have appealed to Caulfield, as it exemplified a vernacular language of everyday life derived from the modern world that is idealised and rendered within the purist language of the post-cubist still life. He forged an artistic vision based on his commitment to both modern form and content that would have found resonance with Caulfield's work.

The 1960s was a period of radical and far-reaching change in Western culture, perhaps the key historical turning point of the twentieth century. The end of the Second World War marked the beginning of the battle to rebuild the country. London's skyline was transformed by new buildings such as the Hilton on Park Lane, The Southbank Centre and Millbank Tower on the Thames. While the Government continued to stimulate commercial redevelopment, art was considered to be a vital part of social change, participating in, reflecting and influencing wider culture. Film, television and magazines created an interest in the wider world while serving as a showcase for consumer goods and by 1960, transatlantic air

7
Still Life with Dagger
1963
Household paint on board
121.9 x 121.9
Tate. Purchased 1976

8

Still Life with Necklace

1964

Household paint on board

91.4 x 213.4

Private collection

travel was no longer the preserve the elite, opening up new horizons to all. The turn of the decade was characterised by optimism that corresponded to increased affluence but also to altering concepts of class taste and status and to new forms of social aspiration in Britain. A new generation of artists that included Caulfield developed ways of dealing with modernity in their work that was radically innovative. Their engagement with the world secured an unprecedented position for art, and for many of the artists themselves, in the eyes of the public.

Prior to taking up his place at the Royal College of Art, Caulfield used the money from two prizes he won at Chelsea, including one awarded by the critic John Berger, to spend the summer of 1960 travelling in Europe. With seven fellow students, including Pauline Boty, he went by train to Greece, later hitch-hiking his way back to London through Italy and France.[18] It was his first trip abroad and he was away for five weeks. On this visit he collected postcards including pictures of Minoan frescos because he 'liked the simplicity and directness' of the images.[19] At the time he didn't realise that the black lines had been added by the printer 'but these cards struck me as being very amusing and quite strong imagery. So I thought about using lines around my own work.'[20] Caulfield appreciated their exotic, decorative

qualities which were to inspire the composition of early works such as *Still Life with Dagger* 1963 (fig.7), where the Mughal (Indian) dagger with horse's head and scabbard were drawn from life in the Victoria and Albert Museum which was next to the Royal College of Art's Painting Department, and *Still Life with Necklace* 1964 (fig.8) where a complex arrangement of Turkish pots, jewelled knives and a necklace patterned with a filigree of fine lines are set against a stark, geometric background.[21] Both works are characteristic of Caulfield's approach to painting in the early 1960s with images of objects paired with angular geometric shapes, isolated against vivid areas of flat colour, which highlight his use of gloss paint on board and hard, linear technique. In each case direct reference is made to the still lifes of the cubist painter Juan Gris (1887–1927). As Caulfield explained, 'What I like about Juan Gris's work is not that he's dealing with different viewpoints, it's the way he does it. It's very strong, formally, and decorative.'[22] While the imagery can be understood as being rooted either in daily experience or in images which are equally familiar through postcards, advertisements or travel brochures, it is important to note that they are often underpinned by a sense of the exotic. In the context of the austere post-war world Caulfield's fascination with the exotic seems an understandable response.

The terms exotic or exoticism are today often treated as synonymous with orientalism and other colonialising discourses. This colonial exoticism is best exemplified by the Great Exhibition of 1851, which was held at the Crystal Palace in London where artefacts of the British Empire were displayed as a spectacle for the crowds. In contrast to the Great Exhibition of 1851, the Festival of Britain which took place in the summer of 1951 celebrated the nation's recovery after the Second World War. Billed as 'a tonic for the nation', the festival was a showcase of Britain's finest architecture, design, fashion, science, arts, manufacturing and creative industries. Everyday life was still drab and grey with many things continuing to be rationed; the everyday exotic was just out of reach for the majority. The festival aimed to convince the war-ravaged country that the future was not so bleak and that they were entering the age of modernity. While the festival took pride in Britain's past, most of the exhibits looked to the future and science and technology featured strongly. Thus at this time the modern can be seen to be both exotic and everyday. Much of the sense of the exotic in Britain in the post-war period was not so much an exoticism of the tropics, of oriental luxury and distant horizons, but was rather a rediscovery of a European and American otherness, exotic yet within easy reach.

2 THE NEW GENERATION

THE 1960S are remembered as a period of optimism and increasing excitement in the London cultural scene as a whole. Popular culture blossomed: fashion, cinema, literature, music and the mass media all generated new modes of visual address. Mary Quant had already inaugurated the British revolution in women's fashion that would give the world the miniskirt, and several of her immediate successors, including Ossie Clark, were students at the Royal College of Art in South Kensington. The British music explosion was about to happen and a large number of musicians including Keith Richards, Eric Clapton, Pete Townshend and Ray Davies were students at art schools in or near London in the early sixties. By 1963 The Beatles were major recording stars and The Rolling Stones were establishing their reputation as rock celebrities. In architectural circles members of the Archigram group were developing visions of the future derived from many of the same sources used by pop painters, and, most significantly of all, the social revolution saw London transformed into 'Swinging London.'

Caulfield started at the Royal College of Art in the autumn of 1960, one year after the arrival at the Painting School of R.B. Kitaj, David Hockney, Allen Jones, Peter Phillips and Derek Boshier. The Royal College had a significant reputation with artists such as Bridget Riley, Peter Blake, Robyn Denny,

Richard Smith and Joe Tilson graduating from it the late 1950s. In keeping with his modest and rather shy personality Caulfield said that he regarded himself as 'lucky to have come in quietly on the second wave and to have kept a low profile'.[1] The school offered Caulfield the opportunity of two years' uninterrupted painting and drawing. A programme of work was set out for students in their first year: drawing and painting from the model, study in the museums and art galleries including the copying or paraphrasing of a picture, practical demonstrations of the techniques and methods of painting, lectures on design, colour and perspective.[2] In many respects this was the heyday of art schools; resources increased and courses were upgraded so that the students were awarded the Diploma in Art and Design (Dip.AD) which brought art and design education into line with developments in the professional arena and gave academic credibility to studio practice. Like Caulfield, many children from working class and lower middle class homes gained access to higher education for the first time. In the art schools this influx brought with it the first stirring of issues that would become more prominent as the decade progressed: new ideas filled the agendas of artists of Caulfield's generation who were keen to re-shape the direction and expectations of artistic production in Britain towards pop-orientated themes and subjects. The student magazine *ARK*, to which a lot of young painters contributed, was a useful barometer of contemporary issues at this time; the first issue stated that the magazine's purpose was to explore 'the elusive but necessary relationships between the arts and the social context.'[3]

As Caulfield explained, he shunned 'the politeness of English Art – dewy landscapes, sensitive drawings of nudes', a reference to the artist William Coldstream (1908–87) and the realist tradition of the Slade School painting that promoted working from direct observation. For Caulfield, his particular choice of subject matter 'came about by a process of elimination. The things I didn't want to do as opposed to the things I did … I wanted to choose something that was alien to my actual daily circumstances, something that had a more decorative quality than art was supposed to have.'[4]

This sense of the decorative can be linked not just to Caulfield's interest in the exotic but also to the rich and decorative aspects of paintings by Henri Matisse (1869–1954), an artist he very much admired. Caulfield appreciated Matisse's use of black to simplify the composition and to set off his vibrant colour palette. At a time when much of British painting was dominated by the Kitchen Sink painters, described by Caulfield as 'muddy social realism

in ochres and black', and characterised by the work of John Bratby, Derrick Greaves and Edward Middleditch, Caulfield looked back to Matisse as a source of inspiration.[5] Moreover debate around the idea of the 'decorative' in relation to painting raged at this time, led by Clement Greenberg, the influential American critic and champion of abstract expressionism, who used the word 'decorative' as a negative term. Preoccupied with the distinction between high and low art, Greenberg was not a fan of mass culture or pop art which he characterised as kitsch, a watering down of modernist innovations, a pilfering of the high by the low. Thus, on one level Caulfield's attraction to the decorative and everyday subject matter can also be understood as a contrary response to the formalism preached by Greenberg that was so prevalent at the time.

Very early on in his career Caulfield rejected gestural brushstrokes for the more anonymous technique of sign-writers: this rejection was shared with the purism of Amédée Ozenfant (1886–1966), Fernand Léger (1881–1955) and Le Corbusier (1887–1965) whose work he also admired. The Purist Group, founded in the early twentieth century, championed the stylised depiction of real objects. Their vision of modern life emphasised a sense of formal order, clarity and harmony. Like Stuart Davis, whose work Caulfield also admired, the purists found source material in the contemporary urban, its shop windows, advertisements or commonplace objects. Caulfield developed his own flat linear description of three-dimensional form in response to Léger whose use of colour, shape and line was rigorous and precisely controlled. Léger drew parallels between his artistic style and that of street advertising – like posters and neon signs, his paintings are bold, graphic and colourful statements about modern life. Caulfield felt that 'the way of describing forms in a linear way, is a very old tradition: it's the simplest method of representation', but was also fascinated by the use Léger had made of commercial gloss paints which enhanced a sense of impersonal objectivity.[6] It was Caulfield's adoption of paint brands such as Crown and Dulux, painted on board rather than canvas, that produced the flat, glossy surface, largely devoid of brush marks, that he wanted.

Artists throughout the twentieth century have chosen to use household paints for a number of reasons: for the unique handling properties and surface characteristics they offer, for social and cultural associations, or simply because they are less expensive than traditional artists' oils. Picasso, for example, used industrial house paint, which he first employed as early as

1912 in order to achieve a variety of surfaces including an almost brushless finish of paint. The use of commercial paints became widespread in the 1940s and 1950s. Pollock, de Kooning and Frank Stella, for example, began to incorporate non-traditional paints into their artworks and, closer to home, Gillian Ayres, Patrick Heron and Robyn Denny also made use of them.[7] This was partly a response to a desire to create textures and effects that could not be achieved using traditional artists' oils, and partly due to a fascination with drawing everyday materials into the realm of fine art. For Caulfield his choice of house paint was 'an aesthetic decision, not anything to do with technique. I wanted a very impersonal surface, I didn't want any obvious brushstroke work that was visible. It was more like a sign-painter's technique.'[8] His interest lay in the material qualities of the medium and as he said he used 'to paint on hardboard because it was cheap … an anonymous surface, the nearest equivalent to the wall'.[9]

During this period Caulfield started to produce highly stylised, linear images of commonplace objects drawn from the still life tradition such as the bottle and glass or flowers in a vase. *Black and White Flower Piece* 1963 (fig.10) is a typical of work from this period. The square format painting was executed in black and white without the relief of colour or tonal graduation, and the

10
Black and White
Flower Piece
1963
Oil on board
121.9 x 121.9
Tate. Purchased with funds provided by the Knapping Fund 1991

11

Landscape with Birds

1963

Gloss paint on board

121.9 x 121.9

Pallant House Gallery,

Chichester (Wilson Gift

through The Art Fund, 2006)

flowers themselves were painted from a squared-up drawing made from life. *Still Life with Candle* 1964 harks back to Dutch *vanitas* paintings of the seventeenth century, which used still life representations to show the brevity of life, depicting the decay of the arrayed objects. Caulfield's objects are characterised by even areas of colour bound by simple black outlines: the glass is on its side, the bread has been nibbled by the mouse and the candle, beside a black Bible, is extinguished. The impermanence that these traditional symbols normally represent is undercut by the bright primary colours and the placement of the objects on a neutral, flat background. The two vivid lines of red and yellow across the picture plane seem to suggest a playful reference to the increasingly effusive expressionism practiced by painters of the generation before him. While Caulfield's approach to subject matter is deliberately at odds with many of the pop artists, he did share with them a desire to clarify the language of painting.

In *Landscape with Birds* 1963 (fig.11), the first painting in which he employed a strong black contour, the geometric shapes which surround the paired birds in flight have precedents in Piet Mondrian's (1872–1944) shift towards abstraction, whereas the composition of *Still Life with Bottle, Glass and Drape* 1964 (fig.12) uses the elements of the cubist still life, the bottle

and glass and so on, but these elements are flattened rather than trying to represent the totality of the object in the cubist manner. Black lines merely suggest three-dimensionality rather than depicting it: their relationship to the red and yellow lines that trace the outline of the bottle and glass is primarily purely formal. As the artist explained 'I merely use the lines as a clear way of defining intentions.'[10] This radical innovation once again owes a debt to Léger's juxtapositions of shape, colour and lines and his merger of traditional still life objects with architectural forms and references to the modern environment, for example *Le Siphon* 1924, inspired by a Campari advertisement which shows a glass and hand holding a soda bottle.

In rejecting the subjects and materials of the 1950s, Caulfield successfully reframed ideas of the modern in ways that blurred the lines of the high-low culture debate of the time. However he did so in ways that were at odds with many of his peers associated with pop art of the 1960s. Back in 1958 the British critic Lawrence Alloway had famously coined the phrase 'pop' in relation to members of the Independent Group such as Eduardo Paolozzi and Richard Hamilton. Alloway used the word to describe work that encompassed imagery taken directly from advertising and popular culture dissolving rigid artistic boundaries. While the term was first applied to works

12
Still Life with Bottle, Glass and Drape
1964
Oil on board
157.5 x 152.4
Private collection

such as Hamilton's *$he* 1958–61 which brought together advertisements for household appliances alongside fragmentary images of a model taken from *Esquire* magazine, a number of artists who emerged from the Royal College of Art in the late 1950s and early 1960s were also associated with it, including Peter Blake, Richard Smith and Joe Tilson, all of whom produced a new kind of figurative imagery drawn from the mass media, including magazines and comics, pop music and the cinema.

While still in his first year at the Royal College Caulfield had two paintings, *Upright Pines* 1961 and *Swaying Palms* c.1961, accepted for the *Young Contemporaries* exhibition of 1961 at the RBA Galleries, London, exhibiting alongside his friend John Hoyland, Boshier, Hockney, Allen Jones, Kitaj and Peter Phillips. This was an important annual survey of student painting, sculpture and printmaking that was considered to be an important litmus test of contemporary practice. Lawrence Alloway's catalogue introduction described how 'A group, seen here for the first time, is of artists (mainly at the Royal College) who connect their art with the city. They do so, not by painting factory chimneys or queues, but by using typical products and objects, including the techniques of graffiti and the imagery of mass communications.'[11]

In a radio talk the following year, Alloway devoted the latter half of it to reviewing what he called a new wave of British pop which he saw exemplified in the 1961 *Young Contemporaries* exhibition. Caulfield had participated in this exhibition but he was quick to shun the pop label and sought to distance himself from the self-consciously contemporary imagery and techniques employed by his colleagues. While Caulfield is often linked to pop art because of his early decision to adopt a flat graphic style, the differences are stark. Rather than looking to America and to the consumerist post-war culture at home for inspiration, Caulfield's main stimulus remained French modernist painting of the 1920s. Even though the still life proved to be a rich subject for American pop artists including Andy Warhol, Roy Lichtenstein and Claes Oldenburg, and to a lesser extent for British artists associated with the movement such as Blake and Hamilton, formal differences are readily apparent. On a whole the pop artists tended towards a flat, emblematic depiction of commercial imagery, or filtered American artefacts through their own experience and set them within the context of their immediate environment. Peter Blake's work, for example, directly reflected his affection for American film and music stars, the ephemera of British youth culture and a nostalgia for folk art, and

Peter Phillips drew on the iconography of advertising and mass media to conjure a sense of modern life which directly alluded to the cultural and the political tenor of the times.

In 1969 the critic Anne Seymour wrote that Caulfield: 'never felt the romantic interest in America which affected many artists around 1960 … It is significant that he felt drawn neither by the techniques of the pop artists, nor to their attitude to the images they used.'[12] Caulfield had less of a celebratory attitude to the modern world even though he was fascinated by style. In the whirl of new experiences and their mediation by mass media Caulfield remains distanced allowing an ironic exploration of his material. This ironic distance is not just playful but a melancholy, romantic irony. His deployment of art historical reference and genre coding allows this melancholy irony to operate, hence his interest in ruins, exoticism and the still life.

Thus Caulfield's subject matter can be understood not as popular culture but rather as grounded in European culture and history and the tradition of genre or still life painting. Caulfield was interested in art history and how images are used to construct a visual language. This is evident from his student sketchbook of 1962 which contains detailed notes on the history of modern painting. Regarding Paul Cézanne (1839–1906), for example, Caulfield notes: '[His] life seems to represent transition from the nineteenth century subject painting to twentieth century concern with form, space and colour', and adds: 'he did not "compose" paintings in a classical sense. [He] chose arbitrarily (perhaps), composition came from the formal treatment - "the paint" not the object painted.'

Pop art often reflected directly on commercial image making processes and consumerist society at large whereas Caulfield's manner refers to a different kind of impersonal style of commercial draftsmanship as found in travel brochures, reflected in the painting *View of the Bay* 1964 (fig.13), furniture advertisements and mail order catalogue illustrations. In his work of the early 1960s he was not so much employing the language of advertising but was more aligned to that of sign painting, making use of simple forms and strong colours. In simplifying the image Caulfield intensifies rather than reduces its potential for meaning.

In later years Caulfield met Roy Lichtenstein at a party for the 1984 Venice Biennale. Lichtenstein was familiar with his paintings and, according to

13
View of the Bay
1964
Oil on board
121.9 x 182.9
CAM – Fundação
Calouste Gulbenkian

Howard Hodgkin, clearly admired them but, as Hodgkin goes on to note, connections between their works can be misleading:

> Both artists were (like so many twentieth century artists) making paintings about paintings, but in Patrick's case they were about feelings as well. Feelings about what it is to be an artist – about friendship and sociability. He was such a connoisseur of spaces where people gather for pleasure, such as restaurants and bars, and he managed to convey in his paintings the melancholy that can haunt such spaces – born of emptiness and artifice.[13]

The vitality of British art at this time was reflected by the first of *The New Generation* series of exhibitions at the Whitechapel Art Gallery in 1964. Selected by Bryan Robertson, Director of the Whitechapel, this was to become an annual event that offered a platform for artists who were 'roughly half-way between leaving art school and becoming established.' Caulfield was included, along with a number of young painters who were reasonably well established: ten out of the twelve had already had commercial exhibitions and Hockney and Bridget Riley were already becoming media celebrities. In his introduction to the catalogue, David Thompson, art critic for the *Sunday Times*, stated, 'The immediate past

14

Portrait of Juan Gris

1963

Gloss paint on board

121.9 x 121.9

Pallant House Gallery,

Chichester (Wilson Gift

through The Art Fund, 2006)

contains two artistic phenomena of special relevance … One was the advent of a "new figuration" – in other words, the much-publicised, ill-named "Pop Art" … Apart from the generally Americanized aspect of modern city-culture that occurs in it, it developed not directly from American example, but from the example of such painters as Richard Smith, R.B. Kitaj and Peter Blake.' He ended his introduction: 'If there are two words that can be said to characterise the aesthetic aims and styles of the generation represented here, they are "toughness" and "ambiguity." The one reflects a desire both to play it cool, be objective, unsentimental … The other can be seen in new colours, new shapes, and in techniques which spurn the marks and traces of the painting hand.'[14]

Caulfield exhibited four paintings: *Portrait of Juan Gris* 1963 (fig.14), *Landscape with Birds* 1963 (fig.11), and two new paintings of 1964, *Still*

15
Santa Margherita Ligure
1964
Oil on board
121.9 x 243.8
Private collection

Life with Necklace (fig.8) and *Santa Margherita Ligure* (fig.15). Though perhaps it was inevitable that the names of those who participated in *The New Generation* exhibition would remain associated with one another there was no great homogeneity in their work overall. Neither was there a collective effort on the part of the artists involved to formulate a school of pop art. For example, while Hockney's *Tea Paintings* of 1960 employ Typhoo tea packets and form an alliance between word and image, his primary focus was to seek ways of integrating personal subject matter into his art and to address the shift from abstraction to realism in his work. He was incorporating of material derived from packaging and advertising into painting that otherwise employed a formal language still owing a good deal to the abstract expressionists. In contrast, Derek Boshier was fascinated by American culture and consumerism and explored its relationship to, and impact on, British culture. For example he made a series of paintings in which he directly referred to toothpaste, which had been the first product advertised on British TV. Nonetheless, in hindsight the work of this generation of artists can be understood as a confrontation between established English culture and a fresh international sensibility that defined the terms of discussion for the rest of the decade. This exchange of ideas would help propel British art to the forefront of international attention.

16
Ruins 1964
from **The Institute of**
Contemporary Arts Portfolio
Screenprint on paper
50.8 x 76.2
Tate. Presented by
Rose and Chris Prater
through the Institute of
Contemporary Prints 1975

3 ROMANCE AND IRONY

THE NEW GENERATION at the Whitechapel Art Gallery in March 1964 was the first time Caulfield participated in a major exhibition and as a direct result he was taken on by the Robert Fraser Gallery in Duke Street, St James's. He had his first solo exhibition comprising eight paintings and one print in January 1965, in one of a few galleries setting up in London which were dedicated to contemporary work and emerging artists.

It was also in 1964 that Caulfield made *Ruins* (fig.16), the first of many screenprints that he would make throughout his career. This was for a portfolio of prints commissioned by the Institute of Contemporary Arts (ICA), London, and printed at Kelpra Studio in north London.[1] It was one of six prints that were subsequently chosen by the British Council to represent Britain at the 4th Paris Biennale in the following year, where despite debate over whether the print was 'hand-made' it won the unofficial Prix de Jeunes Artists.[2] The controversy stemmed from the fact that the silkscreen process, like the household paint Caulfield had used for his early paintings, reflected commercial processes rather than traditional fine art techniques. The screenprint of scattered masonry blocks and desert vegetation set against a yellow background was related to a painting of the same year called *View of the Ruins*, one of five paintings of 'Views' executed on an elongated format.

Again the subject matter reflects Caulfield's attraction to ancient civilisations. This theme and format of composition was also explored in *The Well* 1966 (fig.17), a painting of a roughly built desert well of grey stones alone on a brown field that looks like a caricature of a European idea of an Arab well.

Caulfield worked closely with the printer Chris Prater, producing a full-colour study on board from which Prater would cut stencils for the screens. Caulfield felt that the silkscreen process, with its capacity for printing immaculate large expanses of rich flat colour, lent itself to the formal simplicity of his compositions and that in many respects he had discovered the perfect graphic medium for his work. It was a collaborative process, and in no way a secondary pursuit to painting; Caulfield worked firstly with Prater, who occupied a unique and central position in the development of modern print-making, and later Chris Betambeau and Bob Saich at Advanced Graphics. For a painter who worked slowly the medium offered a means for the wider dissemination of his imagery. As he explained in June 1967:

> For me, silkscreen as opposed to painting is useful in two ways. It provides a smaller format from one in which I would normally want to work if I were painting, and therefore an outlet for images which I want to use but not on a large scale. Also it enables the work to be seen by many more people. This last point is important if only in that it gives another source of information about the nature of the work, other than the usually unsatisfactory photographic reproduction of the paintings.[3]

In 1973 he produced twenty-two screenprints for a limited edition book, *Some Poems of Jules Laforgue*, by the French poet whose work he had encountered when he was a student at the Royal College of Art (fig.18).[4] Jules Laforgue (1860–87) was a pioneer of free verse and his experiments with vocabulary, structure and rhythm in his poetry had a considerable impact on T.S. Eliot and other twentieth-century poets. The qualities that Caulfield particularly admired in Laforgue's poems could also, perhaps, describe his own art; these are poems that Caulfield describes as 'wonderfully concise, managing to be both romantic and ironic.'[5]

As a pessimist Laforgue believed that the futility of the world was best captured by the transient moods of our prosaic day to day existence. Laforgue introduced the objects of everyday life into poetry in a way that at the time was considered shocking. He speaks of 'woollens, waterproofs,

17

The Well

1966

Oil on board

121.9 x 213.4

Private collection

courtesy of

Offer Waterman & Co.

chemist's shops, dreams.' This interest in the quotidian, the banal and the ephemeral has an obvious resonance with Caulfield's work. Laforgue's poetry is not primarily visual as he is more interested in capturing the fugitive nuances of passing feelings: how could Caulfield capture something of Laforgue's poetry in his screenprints?

Caulfield's solution was to present a series of cryptic images of views and objects that, while not representing anything mentioned in the poems, manages to capture something of their abiding melancholy. Thus the patterned floor with a cigarette butt in *And I am alone in my house* is an analogue of the sense of solitude conjured by the accompanying poem. Some of the screenprints verge on abstraction. The first screenprint in the series, *Ah! this life is so everyday* accompanies what is Laforgue's best-known line from his poem 'Complainte sure certains ennuis'. Done wholly in sombre black and deep, blue the picture depicts the corner of a window with a fringed curtain hanging across it. We can see the sky outside with three birds hanging in the sky. This image occurs nowhere in the poem but it captures something of the mood that Laforgue evokes. Even starker in its simplicity is screenprint twenty-one, *Curtains drawn back from balconies of shores* which illustrates 'L'hiver qui vient' from Laforgue's 'Derniers Vers'. Against

a black field, a ragged vertical slash of deep pink again suggests a curtained window that this time looks upon nothing but a small patch of empty sky. In both these works it is implied that the viewer is separated from any contact with the world beyond the room and left only with their thoughts.

The character of these screenprints re-emphasises Caulfield's interest in the *papier collé* of Gris and Braque. Both Laforgue and the cubists utilised the bric-à-brac of everyday life but, while Laforgue was interested in how these objects registered subjectively, Gris and Braque were more concerned with the objective materiality of things. Caulfield admired the use of woodgraining and other textures in the *papier collé* and said that he like the way these works 'gave the impression of being very "real" and admired their "matter of factness"'.[6] This tension between the subjective and objective allowed Caulfield a space in which to explore his subject matter with an ironic distance.

As the critic Mel Gooding notes, *Ruins* introduces at the outset what might be called 'a characteristic tone: an anti-heroic take on subject matter that has a history of gravitas'.[7] In Caulfield's prints (and this is true also of his painting) the 'history of gravitas' that lies behind his imagery is actually that of the history of the still-life, with all the underlying complexity of the genre.

Despite its origins in the frescos of antiquity and its spectacular flourishing in seventeenth-century Europe, the still life has generally been considered a minor form of artistic expression and ranked below the traditional genres of religious and history painting, portraiture and landscape. Pictorial motifs of inanimate objects – arrangements of vases, floral bouquets, and so on – began to appear in late medieval religious paintings as artists developed new techniques for rendering spatial composition and perspective. These increasingly *trompe l'oeil* arrangements were given a symbolic order of moral allegory. For example, flowers represent forgetfulness, while musical instruments, globes and skulls came to represent temporality, the infinite and death. In traditional *nature morte* or *vanitas* paintings, a reminder of mortality always undercuts the depiction of material pleasures. With its emphasis on affluence, luxury and consumption, still life painting came to maturity as a genre in the Netherlands, Germany and Spain in the seventeenth century reflecting a burgeoning secularism and the economic boom brought on by a new class of merchant traders. It quickly attracted specialists such as Georg Flegel, Ambrosius Bosschaert, Louise Moillon and Juan Sánchez Cotán (of whom Caulfield was a particular fan). Depictions

18
Selection of
twelve prints from
**Some Poems of
Jules Laforgue**
1973
Twenty-two screenprints
on paper
Each 41 x 35.9
Tate. Purchased 1976

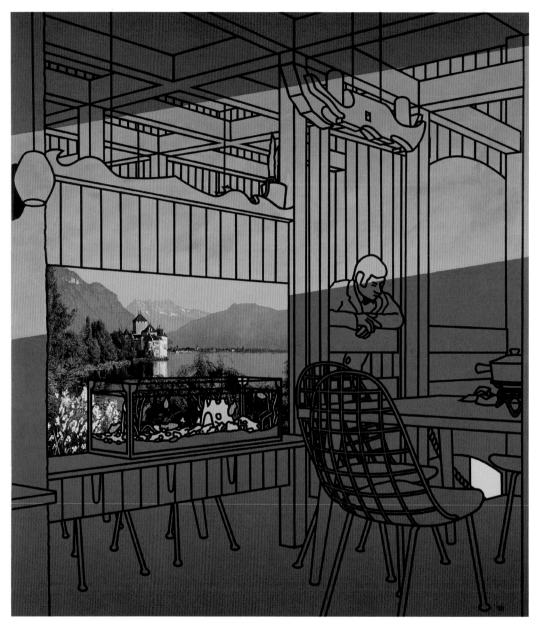

19
After Lunch
1975
Acrylic on canvas
248.9 x 213.4
Tate. Purchased 1976

of fine china and crystal, exotic fruits and flowers were celebrated for their painterly excellence as much as for the materialist aura of the goods displayed and yet they were often subtly coded by choice and assembly of fruit and flowers ripening and blooming at different seasons, or by depictions of tables in disarray, their overturned glasses and abandoned delicacies evoking material waste. The formal invention and transgressive subject matter of French eighteenth-century and nineteenth-century realist painting gradually overturned conventional academic structures and the still life became the preferred vehicle for experimentation. This exploration of the still life led ultimately to the abstraction and the non-figurative found in cubism. This was a new form of painting invented by Braque and Picasso between 1908 and 1913, working from Paris. Important contributions were also made by Gris and Léger. In 1925 Gris wrote that at the start cubism was 'simply a new way of representing the world'.[8] A new way that is, of representing three-dimensional reality on a two-dimensional surface. The old way, the naturalism of the Renaissance, depended upon one fundamental assumption – that everything in the picture is seen from a single, fixed viewpoint. Cubism's 'new way of representing the world' was the abandonment of this rule. The cubists wished to celebrate the simple pleasures of everyday life and its environment, an aim that built on the work of Gustave Courbet (1819–77) and Edouard Manet (1832–83), and the impressionists and post-impressionists.

Early cubist art deals with the figure and the landscape but its predominant subject is the still life, which was elevated to a prominence not seen since the seventeenth century. Much of the source material for Caulfield's paintings follows that of the cubist still life, which deals principally with the café – drinking, smoking, cards, newspapers and with the pleasures of the table. For the cubists the bric-à-brac of the café table represented the experience of modern life: it was only one aspect of modern life, however, and one that was implicitly the preserve of the bohemian and the bourgeois. The use of newspapers in these cubist collages perhaps serves to represent the wider world beyond the café but they are perused at a remove by those leisured enough to while away their time in the cafés.

In Caulfield's practice there is a recurrence of images of drinking and eating in bar and restaurant interiors such as *Paradise Bar* 1974 (fig.43) and *After Lunch* 1975 (fig.19) or as in *Still Life: Autumn Fashion* 1978 (fig.20) and *Un gran bell'arrosto* 1977 (fig.21), an arrangement of meat and vegetables

that reoccurs as a favoured theme throughout his career. In this work a plethora of foods and implements in a kitchen are gathered together, the black outlines and brown background highlighted by sparing use of colour: red tomatoes, green salad leaves and so on. The outer surface of the joint of meat is, oddly, light blue – this use of non-natural colour highlights it as the focus of the composition. What is most peculiar about the picture, however, is the fountain seen through the window. In contrast to the stylised graphic design of the kitchen, the fountain is rendered much more realistically; the contrast of styles is jarring and provocative. By bringing such disparate styles together, Caulfield may be inviting us to consider how we decode or understand different pictorial languages.

Caulfield often simply portrayed 'ordinary' subjects such as the red stove in *The Corner of Studio* 1964 which references a Delacroix work of the same title. In a still life such as *Still Life: Mother's Day* 1975 (fig.22) three objects are depicted at the centre of the canvas: a telephone, a bowl or vase and a lamp set upon a table. These objects are outlined in stark black upon a uniform flat pink field and shadowed in equally flat blue. Within the outline of the bowl is a pink rose which is rendered naturalistically. The rose is the focus of the work, its realism contrasting with the stark

20
Still Life: Autumn Fashion
1978
Acrylic on canvas
61 x 76.2
National Museums
Liverpool, Walker Art
Gallery. Purchased with
the aid of grants from
the Calouste Gulbenkian
Foundation and the V&A
Purchase Fund 1979

21
Un gran bell'arrosto
1977
Acrylic and oil on canvas
76.2 x 91.4
Astrup Fearnley Collection

22
Still Life: Mother's Day
1975
Acrylic on canvas
76.2 x 91.4
Clodagh and Leslie
Waddington

simplicity of the rest of the work. While Caulfield learnt a great deal from American precursors of pop, especially Stuart Davis and Edward Hopper, his many still lifes are almost always modulated by that of cubism and its incorporation of newspapers, cigarette packets and other everyday items into their compositions. In Caulfield's case this is translated into a wine glass, modern chair or lamp – seemingly commonplace and ordinary but more complex than they at first seem due to their modernist resonance.

Caulfield's admiration for Gris's work gave him the excuse to paint *Portrait of Juan Gris* 1963 (fig.14), one of the very few images of a figure he made. For the rest of his life he confined himself to picturing only the suggestion of human presence. This was a conscious decision, born of the view that 'Picasso had pulled the plug on interpreting the human form'.[9] Preparatory drawings reveal that the work began as a portrait of Cézanne, an artist Caulfield also respected. However, during the course of his preparatory drawings he changed the figure to that of the Spanish artist.

In the painting Gris is shown half profile (the head is derived from a photograph taken by Man Ray in 1922, reproduced as the frontispiece to James Thrall Soby's monograph, *Gris* (1958)), wearing a blue suit against

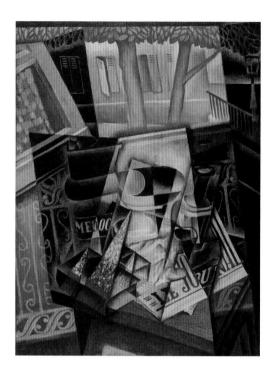

a bright yellow background. Caulfield's hero is surrounded by geometric forms that allude to Gris's complex spatial compositions. Caulfield purposely chose the painting to be as bright as possible because he thought of his work as being optimistic and a contrast to the 'grey' of the artist's surname. He liked the fact that so much of Gris's imagery was associated with bars and cafés and was impressed by how Gris could be so inventive despite using such a small group of motifs. He also admired Gris's ability to paint partly from life and to collage objects together in his mind to create a sense of unity. This compositional dovetailing of objects may have subsequently had an impact on Caulfield's approach to his mature work, where *trompe l'oeil* and photo-realism co-existed happily alongside simple graphic outlines, emboldened planes of flat colour and perspectival complexity that allowed for more sculptural interpretations of the depicted scene. Both artists had the ability to reconstruct the world anew in their imaginations, creating new formal structures that rendered the most mundane objects and scenes memorable.

Gris's *Still Life before an Open Window, Place Ravignan* 1915 (fig.23) contains some of the traditional objects commonly associated with still life – a bowl of

23
Juan Gris
Still Life before an Open Window, Place Ravignan
1915
Oil on canvas
115.9 x 88.9
Philadelphia Museum of Art. The Louise and Walter Arensberg Collection, 1950

fruit, a bottle and a glass, a newspaper and a book – all carefully arranged on a table top at a balcony window with railings. Every element of the painting was considered with Gris's particular precision: line, shape, tone, colour and pattern were carefully refined to create an interlocking arrangement free from any unnecessary decoration or detail and so that the composition is flattened into a grid of overlapping planes. Caulfield admired the nocturnal tonalities of this work; sections shift from light to dark, positive to negative, monochrome to colour, transparency to opacity, and from lamplight inside the room to moonlight outside. The relationships of these juxtaposed elements leave us with a sense of the still life group in its surroundings – the kind of fragmented sense that our memory would retain had we seen them for ourselves. As Caulfield explained in an interview in 1998:

> Juan Gris remains an important source for me. His paintings are small by modern standards but grand in their structure, and they have real atmospheric colour. Gris painted imagined reality, things remembered and formalised. These 'things' – usually objects associated with cafés – were common currency among Cubist painters, but Gris's vision was highly individual, based on intense personal observation and interpretation. He managed to snatch Cubism from its shared theoretical basis and make it his own language, extending its possibilities. It was not only his aesthetic language that I responded to. His motif – café life – appealed to me because my own work revolves around similar urban images, which I like reconstructing from close – perhaps too close – observations of reality.[10]

In 1966 Caulfield had his first American one-man show at the Robert Elkon Gallery in Manhattan. He subsequently showed once in 1974 with Ivan Karp at O.K. Harris Works of Art in Soho, New York, where he exhibited a large group of canvases. However the American market always proved rather elusive for Caulfield, where his ironic handling of subject matter often proved resistant to sustained critical response.

The following year, 1967, Tate became the first major public collection to buy Caulfield's work when they acquired *Battlements* 1967 (fig.24), one of several paintings of simplified architectural details seen in close-up. A painting of a *Parish Church* made in the same year was based on a line drawing of a typical country church which Caulfield found illustrated in a book, *The Parish Churches of England*.[11] This diagram appealed to Caulfield's interest in creating generic images. *Battlements* and a related

painting, *Stained Glass Window* 1967, represent fragments of this fictional church. Because he wanted to represent his subjects at life size he began for purely practical reasons to paint on canvas – using hardboard restricted the size of his work because it was only available in a maximum width of 4 feet (121.9 cm). This interest in depicting things at life size extended from the scale of vases in a painting such as *Red and White Still Life* 1964 to other objects such as *Smokeless Coal Fire* 1969, *Stereophonic Record Player* 1968 (fig.25) and *Bathroom Mirror* 1968, reflecting the geometric fragmentation of the surrounding tiled bathroom, all representations of familiar things that can be understood within the category of the still life while at the same time signalling a shift in direction towards an interest in the modern interior or architectural environment. As Caulfield said:

> I find man-made things always intriguing, from sophisticated design to cruder street or shop signs. I like the language of visual communication at any level, not just in high art as in Rubens or Velásquez. I've always like urban imagery as opposed to landscape or 'nature'.[12]

The concern to give a logic to the scale of his paintings led Caulfield to

24
Battlements
1967
Oil on canvas
152.4 x 274.3
Tate. Purchased 1967

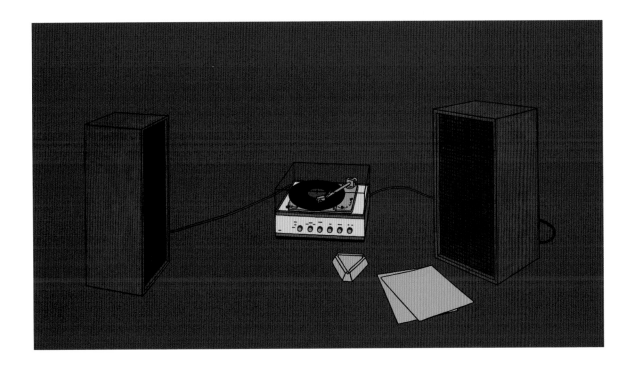

start painting domestic and public interiors on larger canvases so that they appeared to be 'room sized'. This may also be related to his general interest in environments and stage sets: he constructed complex battlefields for war games and sets for pantomimes that he designed for plays with friends including Peter Ward and the artist Nicholas Munro.

Battlements consists of a single row of crenellated battlements that crosses the canvas at a slight angle. Their three dimensional form is characteristically outlined in black. As with *Stained Glass Window* and *Parish Church*, the artist has detailed the occasional crack and chip in the stonework which counters the decorative patterning of the composition. This gives a sense that the scene was derived from a real object rather than being an invention of the artist's imagination. The atmosphere is similar to that of a slightly earlier painting *View of the Rooftops* which depicts a series of chimneys rendered in a similar manner against an empty red background.

In 1968 Caulfield married Pauline Jacobs, whom he met at Chelsea Art School. They had three sons, Luke (b.1969), Louis (b.1972) and Arthur

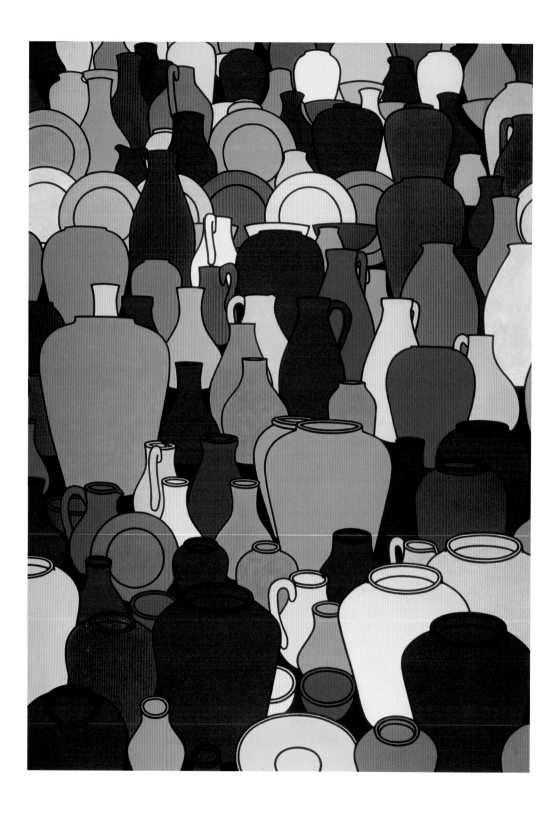

(b.1979). The family first lived in a rented flat in Clarendon Road near Ladbroke Grove, west London, before moving to a house in the same area. With the demise of the Robert Fraser Gallery, Caulfield joined The Waddington Galleries on Cork Street. This was established by Victor Waddington in 1958 and initially represented Jack Yeats, Ivon Hitchens, Elisabeth Frink and a number of the St Ives artists including Bryan Wynter, Patrick Heron, Terry Frost and Roger Hilton along with the French painter Henri Hayden. In the early to mid-1960s it began to show the American painters Milton Avery and Richard Diebenkorn along with the British sculptors Tim Scott and Isaac Witkin. Victor's son Leslie Waddington, who was to become one of the most influential dealers of his generation, was keen to develop the representation of contemporary art and to further this goal, with the financial support of television executive Alex Bernstein, set up a second gallery on Cork Street in 1966.

Caulfield's first solo exhibition with the new gallery was at Waddington Prints Gallery in December 1968. This was followed the next year by an exhibition of six new paintings and five new screenprints. A number of these paintings reflected a further shift in scale. *Pottery* 1969 (fig.26) was one of his first large paintings on canvas and also one of his first works to be executed vertically, rather than flat on a table, which up until this point had been Caulfield's preferred way of working. All the paintings were on canvas and at this time Caulfield was still using commercial oil-based paint. However towards the end of the decade he began to use acrylic. Caulfield claimed that '*Pottery* was an excuse for me to use a lot of colour … it is simply an extravagant elaboration of the pottery still lifes that I had done previously.'[13] While he was unfamiliar with William Nicholson's painting *The Hundred Jugs* 1916, both works, in contrast to more conventional still-life arrangements depicting a single jug with flower, display a profusion of jugs. The pots in Caulfield's painting are depicted from different perspectives according to where they are placed in the overall composition. Those at the bottom of the work appear to have been painted from above, so that the viewer is looking down over their open rims. However, irrespective of whether an object is depicted in the foreground or the background, the evenness of the line is the same so that it rather denies the illusion of space, despite representing it. This shift in the scale of paintings also coincided with a shift in subject matter to work that more directly engaged with the contemporary social landscape and the representation of modern life.

26
Pottery
1969
Oil on canvas
213.4 x 152.4
Tate. Presented by Mrs
H.K. Morton through
the Contemporary
Art Society, 1969

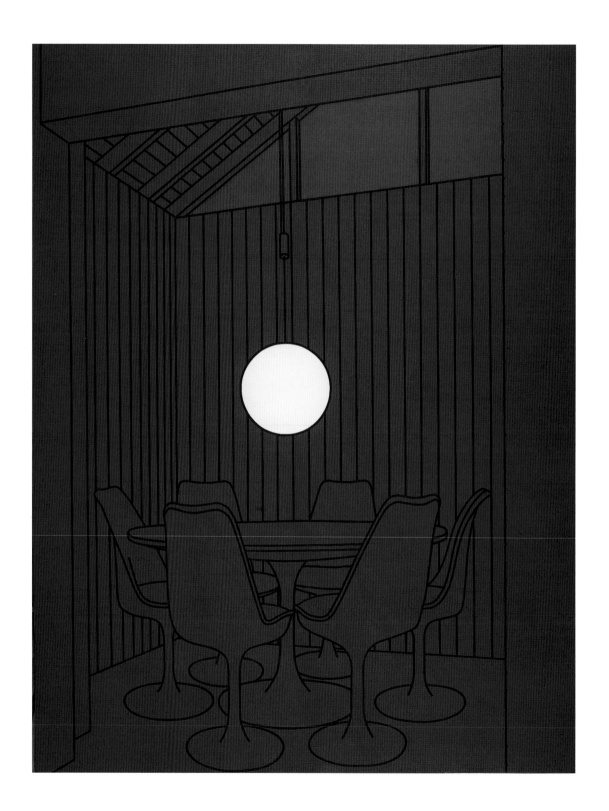

4 MODERN LIFE

CAULFIELD CAN BE REGARDED as quintessentially
modern in his engagement with everyday life. Finding his subject matter
in the world around him, from this period onwards his interest in the built
environment can be understood primarily as an area of affective involvement
and of transient emotions and pleasures. The architectural pictures and
interiors he depicts have a sense of the new, post-war world, tinged with an
abiding sense of melancholy. This is in keeping with his interest in the history
of European painting and the possibility of reinvigorating traditions in a
subtle manner. In the middle of the nineteenth century a generation of French
artists, led by Courbet, turned away from the concept of History painting
which had dominated European art since the Renaissance. Courbet and
Manet rejected such subject matter as remote and often incomprehensible
and insisted instead that art should reflect modern city life, ordinary human
experience and middle class leisure.

27
Dining Recess
1972
Acrylic on canvas
274.5 x 213.5
Arts Council Collection,
Southbank Centre, London

Writing in 1863, poet and critic Charles Baudelaire (1821–67) urged artists
to depict the landscape of modern life, in particular to capture the urban
environment of Paris in the 1860s. His essay 'The Painter of Modern Life'
called for artists to carry through the shift in subject matter that had already
begun in the practice of Courbet, Manet and others. Baudelaire defined

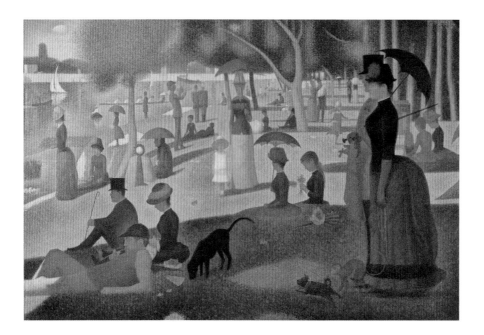

modernity as 'the transient, the fleeting, the contingent'[1] and thought that the
artist should strive to capture the ephemeral world of boat trips on the Seine
and popular singers in the cafés on the new boulevards. This new Paris was
epitomised by paintings such as *A Sunday on La Grande Jette – 1884* 1884–6
(fig.28) by Georges Seurat (1859–91), which depicted a Sunday afternoon
with people relaxing in a park on an island in the River Seine, or Manet's *A
Bar at the Folies-Bergère* 1881–2 (fig.29), that focused on a young woman
who worked at the Folies-Bergére, one of the great Parisian café-concert halls.
In this latter work, the barmaid stands alone, looking distracted, the crowded
room reflected in the mirror behind her.

Baudelaire believed in 'the epic quality of modern life' and that 'since every
age and every people have had their own form of beauty, we inevitably have
ours'.[2] Caulfield shares with Baudelaire this interest in modern life and a
sense of irony, tinged with melancholy. In his *Journeaux intimes* (*Intimate
Journals*) Baudelaire expanded on this view in his definition of beauty. The
beautiful is a confused mixture of 'pleasure and of sadness; conveys an idea
of melancholy, of lassitude, even of satiety – a contradictory impression, of
an ardour, that is to say, and a desire for life together with a bitterness which
flows back upon them as if from a sense of deprivation and hopelessness.'[3]

28
Georges Seurat
**A Sunday on La Grande
Jette – 1884**
1884–6
Oil on canvas
207.5 x 308.1
The Art Institute of Chicago.
Helen Birch Bartlett
Memorial Collection

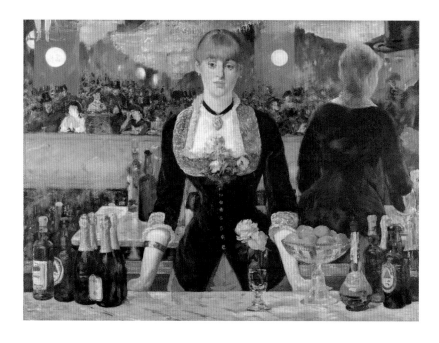

He adds that 'Mystery and regret are also characteristics of the Beautiful.'[4] This definition of beauty can be applied to Caulfield's work: the complex co-existence of pleasure and unease characterises the mood that Caulfield evokes. Both Baudelaire and Caulfield are ironic or distanced observers who sense the melancholy undertow of the passing show of life.[5]

Caulfield's detached, ironic and melancholic stance (shared with Laforgue as well as Baudelaire) gives us his implied view of the human condition. In some of his paintings the sense of loneliness, the subdued angst and seeming indifference of objects to human values that Caulfield so subtly depicts echoes the existential view of humankind. Like Hopper, Caulfield explores the emotional valence and moods that form part of the most banal aspects of existence. Caulfield would have us look again at the surface of our cities – our bars and restaurants – as the fundamental frame of reference for modern life. In 1985 he relocated from working in Charterhouse Square in the city to a studio in Archer Street in the heart of Soho. Two years later he moved to live with the artist Janet Nathan in Belsize Square. For the last twelve years of his life he also had his studio there. Caulfield continued to find inspiration in aspects of urban life that most of us fail to notice, in the fissures and the discrepancies only spotted by someone immersed in the chaotic artificiality of the city and who has the intention of celebrating

it, from the prominent 'EXIT' sign glimpsed in the corridor of the main bar in *Happy Hour* 1996 (fig.49) to the William Morris wallpaper juxtaposed against the rungs of Victorian banisters in *Green Drink* 1984 (fig.30).

His imagery is readily drawn from the realm of the familiar, which he treats in a formalised manner. While relying on postcards, tourist brochures and advertisements to develop the clean cut style he favoured, Caulfield introduced a disquieting note as well. The convivial interiors – hotel foyers, restaurants and pubs – take on a cool, detached atmosphere, which is achieved through a conspicuous absence of human presence and by containing the objects within fixed, rigid lines. This method maximises their presence and suggests a symbolic content, though no further meaning is explicated. Caulfield commented, 'If you're depicting something made by human beings that seems to me to be enough.'[6] Caulfield is master of the prosaic and unheroic side of urban life. And yet his paintings often seem touched by a strong sense of ennui or solitude. They register a complex and sophisticated response to the central problem of expression. The interest is in the thing – people appear only belatedly or contingently. For example, *Concrete Villa, Brunn* 1963 (fig.31), includes a self-portrait of the artist sitting up high on the roof terrace of a modernist house.[7] As he explained, 'That was really because I was in love with that architecture.'[8] Although much of Caulfield's subject matter revolves around the implication of human habitation, figures are rarely seen. The places he depicts have a sense of a new world but also a palimpsest of past styles. The classical heritage, the sleek International style and the contemporary modern co-exist and seem to depict a space where a sense of melancholy can sit alongside the utopian promise reflected by architectural design. Rather than a projective 'futurism', Caulfield observed the modern world as it is, with the past rubbing shoulders with the modern, the chance encounter of different or unusual elements which he so enjoyed in architecture.

Caulfield's work can be understood as a reaction to the burgeoning of mass culture, especially as it is reflected in the increased leisure time in post-war Europe. Art historians such as T.J. Clark and Hal Foster have helped us see how the great painters of modern life – from Manet to Caulfield a century later – are able to both celebrate and critique everyday life at the same time. Clark, for instance, argues that modern art emerged from these painters' attempts to escape the rigid formality of the academic tradition and to represent the new city of Paris of the 1860s and 1870s, newly adorned with boulevards, cafés, parks and suburban pleasure grounds.[9]

30
Green Drink
1984
Acrylic on canvas
76.2 x 111.8
Private collection, UK

Writing on art created a hundred years later, Hal Foster claims that the consumer societies which emerged after the Second World War created a totally new image-world.[10] The birth of this new consumer society marks an important difference between Baudelaire and Caulfield: the nature of modernity itself has mutated and a whole new aspect of it has been revealed, one that Baudelaire had no experience of. Caulfield's work seems to suggest, though, that there is not such a great divide and that the common human lot still engenders a similar ironic distance rooted in melancholy.

Caulfield's work engages with the contemporary social landscape but in a way that has often been open to misinterpretation. Christopher Finch rightly disagrees with those who see Caulfield as a belated cubist depicting visual clichés: 'the critics who have seen in these just a clever re-hash' of what happened fifty years ago have entirely missed the point.[11] What is important is not that Caulfield is making self-referential art about art, but that he is dealing with the social reality of a life that is now increasingly mediated by images. In this sense Caulfield remains true to modernity's project of reflecting everyday life. One instance of this interest is Caulfield's use of postcards in addition to French recipe cards (fig.48), interior design books (fig.32), seed catalogues and photographs as composition aids for his work.

He remarked, 'I keep them but I don't collect them. People send me postcards and I don't throw them away, that's all. I have no filing system of material.'[12]

Santa Margherita Ligure 1964 (fig.15) was the first of many of Caulfield's paintings based on a Mediterranean theme and as such it is a major contrast to the references to contemporary culture in the work of many of his peers. The painting is of a view from a balcony, looking out onto the harbour scene beyond, where a white yacht is sailing in the bay. It is a world as far removed from his birthplace in Acton as could be imagined. In the foreground there is a round table on which is placed a large vase full of red and white roses. The vase of flowers, railing and façade were taken directly from a postcard as was the colour scheme. The artificial colour of the cheap reproduction has undergone an equal distortion in the painting, translated into the highly saturated flat gloss of Caulfield's surface. Heightened beyond expectation the terracotta of the flowerpot on the right-hand side of the postcard has been painted a blazing Indian red, the same colour as the roses in the flower arrangement. Unlike the postcard the central view is framed within a painted border. The interior-exterior character of the picture was a departure for Caulfield and thus looks forward to the paintings of the mid-1970s such as *After Lunch* 1975 (fig.19) or *Still Life: Maroochydore* 1980–1 (fig.33).

31
Concrete Villa, Brunn
1963
Oil on board
121.9 x 121.9
Private collection

32
Spread from
**Decorative Art: The Studio
Year Book 1958–59**
One of a number of design
books used as source
material by Caulfield

In *Santa Margherita Ligure* and similar works, Caulfield is responding to the growth of mass tourism. While not consciously commenting upon the growing opportunities for travel that opened up for the majority at this time, Caulfield certainly benefited from this enlarging of horizons. In previous generations someone of his background would not have expected to travel widely abroad. Mass tourism and the proliferation of images of the world via television and other media held out the allure of the exotic while at the same time making it seem domesticated and unthreatening. Caulfield's use of postcards as a source for his paintings is an instance of such images – more intimate than pictures on a screen and implying a sender and recipient. European mass tourism was predominantly to the Mediterranean countries. As well as sun, sea and sand, the Mediterranean suggested a more leisured existence imbued with classical culture (even if just at the level of ruins). It is this world, at once real and imaginary, that Caulfield depicts.

The picture-postcard prettiness of these works harks back to early twentieth century French painting – echoing artists such as Raoul Dufy and Matisse. Dufy's seaside scenes are characterised by vivid colour and a sense of *joie de vivre* and Matisse's paintings made in the coastal town of Collioure (for example *The Open Window, Collioure* 1905) use a

view through a window – a recurring motif. But Caulfield's inventiveness counters any sense that the paintings were an attempt to imitate the earlier masters. Like the harbour scene *View of the Bay* 1964 (fig.13), made during the same year, *Santa Margherita Ligure* was directly based on a postcard he bought while on holiday with a girlfriend in the Italian town in 1964. He painted not the landscape itself but a postcard of it, as if he wasn't really there but seeing it at one remove. The extended horizontal format is characteristic of many of his works made between 1964 and 1968 including *Bend in the Road* 1967 (fig.34), where the motif of the road extends into the distance.

This use of found images continued into the 1970s when Caulfield began combining different styles of representation, such as *trompe l'oeil*, to create highly complex paintings of great originality. In these paintings his use of photographic images as reference material is different to that of the photo-inspired works of contemporaries Gerhard Richter, Vija Celmins, Richard Artschwager or Malcolm Morley. Their work, in very different ways, engaged with ways of mediating and manipulating photographic or mechanically reproduced images from mass media, deconstructing a traditional understanding of 'realism'.

33
Still Life: Maroochydore
1980–1
Acrylic on canvas
152.4 x 152.4
Clodagh and Leslie
Waddington

34
Bend in the Road
1967
Oil on canvas
121.9 x 213.4
Collection of the Musée
national d'histoire et
d'art, Luxembourg

In the case of *Still-life on a Table* 1964, where a patterned vase and bowl sit on a blue café table, Caulfield makes direct use of the illustrations from a book on Turkish pottery published by the Victoria and Albert Museum. The 'Tulip' chairs and table designed by Eero Saarinen in *Dining Recess* 1972 (fig.27) were taken from photographs in books on interior design published in the 1960s such as *Decorative Art in Modern Interiors* and *Continental Interiors for Small Flats* where he often annotated points of interest, for example, the room's ambient atmosphere, the way shadows are cast by a lamp or a group of pictures on a wall that appear more like windows looking out onto a world beyond.[13] The recess contains a table and six chairs set against the vertical wooden slats of the wall. The entire work is in a sombre grey except for the blue of the sky seen through a high window and the perfect sphere of a globe lamp in a pale yellow. The circle of the lamp is delineated by a black line that seems to contain the light. Neither the lamp nor the light from the window relieves the uniform grey gloom; the furniture has no shadowing to suggest three-dimensionality, remaining resolutely flat, refined from its source in photographic images.

While pop art often presented pictures of mass-produced images divorced from any context, Caulfield's paintings of everyday life were redolent with allusions to lifestyle and the wider contemporary social environment. This reflects a

practical engagement with and exploration of everyday life in modernity. This is not, of course, to say that Caulfield is totally uncritical of the proliferation of such images: he was highly attuned to their aspirational nature, but nevertheless he favoured images of objects that were generalised in terms of their use because that is what he saw around him. As Caulfield wrote in 1970, 'The subjects are imaginary, so that they are particular yet stereotyped images.'[14]

Inside a Weekend Cabin 1969 and its companion piece *Inside a Swiss Chalet* 1969 (fig.35) are two large scale vertical interiors that reflect a shift in Caulfield's subject matter from still life to architecture. Executed vertically rather than flat on a table, this perhaps explains a new interest in perspective. Both works are of unpopulated imaginary interiors, again inspired by books on interior design. Their limited colour palette and rigorous absence of modelling and shadows reflects the artist's growing confidence in his own visual language. The interiors consist of familiar objects and invented places that create the illusion of three-dimensional space through clever use of two dimensional forms and devices. The viewer is encouraged to feel as if they are walking into the room, which is maximised by the large scale and perspective at eye-level.

In the former, Caulfield's use of perspective gives an illusion of depth to the corner of this basic pastoral retreat with its unlaid table and scattered stools, the black linear description of forms contrasting with the abstract flatness of the brown background. The brilliant plain white table-cloth is painted in acrylic as opposed to oil to keep its whiteness for longer. As the artist explains, 'This is the object introduced into the interior for the "weekend". It is emphasised in the painting. Its reflected light is real rather than being an area painted to represent the effect of light.' The subject matter of *Inside a Swiss Chalet,* with its beams and bunks, is taken from illustrations in an article on 'Week-end Houses and Cottages' in a 1930s interior design book. The author of the article sets such buildings within their social context: 'The habit, which since the war has become world-wide, of seeking health and recreation in the country after a sedentary week in town has naturally had its effect on architecture. All over the countryside and round the coasts has sprung up a mushroom swarm of little houses, cottages and bungalows which can be reached by car or train in an hour or so.'[15] In the painting a sense of location is established by the heart-shaped motifs in the wooden chair backs, which offers an illusion of rustic charm, a make believe fairy-tale like Hansel and Gretel.

35
Inside a Swiss Chalet
1969
Oil on canvas
274.3 x 182.8
Museo Nacional Centro de
Arte Reina Sofía, Madrid

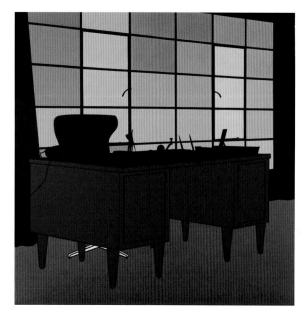

His move in the late 1960s to working with a larger format enabled Caulfield to present flat, linear images of commonplace objects in complex architectural settings, which become his main subject matter. This marks a subtle shift in his use of architectural space. In *Villa Plage* 1970 and *Bistro* 1970 Caulfield's painting is pared down further still with the space and content described only by black contour lines against one strong background colour.

By 1971 Caulfield was in a position to give up teaching. The same year Penguin published a monograph on his work by the critic Christopher Finch, who described him as a 'romantic disarmed by his own sense of irony'.[16] Subsequent works of the 1970s such as *Inner Office* 1973 (fig.36), *Interior with a Room Divider* 1971, *Dining Recess* 1972 (fig.27), *Foyer* 1973 (fig.37) and *Café Interior: Afternoon* 1973 (fig.38) also focus on the subject of the interior, updated and reconfigured in Caulfield's trade-mark style to capture the character of modern life. *Dining Recess* takes its imagery, like other works of this period, from out of date design manuals. *Café Interior: Afternoon* represents a generic modern café. The orange of the chairs, the pinks of the walls and the stripped down design are bland but complicated by the slanting dark bars that cut across the picture. The thicker, central dark bars seem to show the play of light and shadow from an unseen

36 [above left]
Inner Office
1973
Acrylic on canvas
213.4 x 213.4
James Moores Collection

37 [above right]
Foyer
1973
Acrylic on canvas
213.4 x 213.4
Collection David Bowie

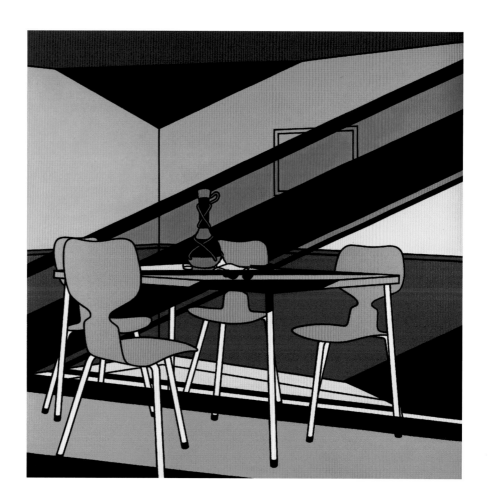

38
Café Interior: Afternoon
1973
Acrylic on canvas
213.4 x 213.4
Private collection

window to the right: this certainty is undercut by the thinner strip which slices ambiguously through the legs of the chairs and does not seem to suggest a source of light. The interweaving of these bands with the furniture turns the banal scene to one of formal complexity. There is a bottle, a pipe and a few pieces of fruit on the table but the meal is over and the diners have left leaving a deserted and melancholic space. *Dining Recess* and *Café Interior: Afternoon*, like other interiors of this period, depict places given over to worldly pleasure but they are often awkward spaces: corners, recesses, rooms hedged in by cross-beams or furniture and so on. The effect produced is a feeling of mild claustrophobia, as if these places ultimately deny the expansive unfolding of leisure or repose that they promise.

As Marco Livingstone notes, 'The leatherette chairs of *Interior with Room Divider*, the moulded plastic seats of *Café Interior*, the ubiquitous Scandinavian design of the furniture in *Dining Recess*, all suggest slightly outdated suburban nouveau riche interiors.'[17] Caulfield is registering the same aspirational *milieu* that he deals with in his Mediterranean paintings; a world created by mass consumerism and inflected by class, but he does so, importantly, without being judgmental.

In a catalogue introduction for Caulfield's solo exhibition at the Scottish Arts Council Gallery, Edinburgh in 1975, Norbert Lynton wrote:

> His theme is not holiday hotels or bourgeois comforts but their established iconography. It is the media's image of things he seizes on, not the things themselves; he is not commenting on objects or their manufacture, but on the way we are tending, or are being pressed, to see even quite ordinary things in unreal falsifying terms that drain away any value they might have had.[18]

For example, *Tandoori Restaurant* 1971 (fig.39) does not show a specific restaurant but is an image of the artist's idea of what an Indian restaurant looks like. Though Indian cuisine had been available in London from the beginning of the nineteenth century, it was during the 1950s and 1960s that the Indian restaurant as we know it today began to spread throughout Britain. Going out for a curry became one of the new leisure time activities, both convivial and, at least originally, exotic or different. Caulfield's treatment of the Tandoori restaurant is more equivocal than Lynton would suggest and reflects his ironic, non-judgemental distance: is the iconography

39
Tandoori Restaurant
1971
Oil on canvas
274.3 x 152.4
WAVE Wolverhampton
Art Gallery

of the restaurant 'falsifying' or rather does it suggest a possibility of real pleasure, however fleeting?

Springtime: Face à la Mer 1974 (fig.40) and *Sun Lounge* 1975 are two important examples of mid-1970s paintings on architectural subjects. The paintings share similar subject matter in that they both contain suggestions of holidays and leisure time. Caulfield provided just enough visual information to create a palpable sense of atmosphere, leaving the viewer's mind to fill in the detail. *Springtime: Face à la Mer* for example, is a romantic painting promising sun-filled holidays and a sea view but the viewer is presented with the side of residence adorned with green shutters, in front of which is a tree just coming into bud. The painting has a dream-like quality to it that reminds one of the haunting paintings of René Magritte (1898–1967), for example the series of paintings *Empire of Light* 1953–4. In Caulfield's painting there is no glimpse of the sea beyond and yet this is hinted at by the blue light radiating from within the building and the sense of a sea breeze gently blowing a net curtain. Caulfield seldom paints exteriors, but when he does they are always at second hand. This painting highlights how Caulfield's approach to image making continued to be the result of a combination of elements: the architectural façade was taken from a book of Mediterranean villas and the tree in the foreground drawn directly from one outside his studio in Cornwall Crescent, west London. During this period he would plan his detailed paintings carefully in advance using precise squared-up drawings, sometimes even transferring the entire composition from a full-scale felt-tip pen drawing on polythene.

Sun Lounge exemplifies Caulfield's stylised and dynamic use of intense saturated colour. The arrangement of comfortable seating suggests an inner courtyard of a hotel, perhaps with pool out of sight, where one might be able to relax and enjoy the sunshine. Most impressive of all is the sense of light that Caulfield achieves in the crisp blocks of colour which give the painting a palpable physical reality. Leading up to this date Caulfield had become increasingly interested in the different effects of light, and in this work the play of light and shadows achieves a dramatic result. With his increasing control Caulfield was able to invest his paintings with subtlety, allowing for a richer complexity to inhabit his world of empty hotel terraces, bars and cafés. As one's eyes adjust the viewer is drawn in, noticing the painting's spatial ambiguities, which include the detail of what may be a hotel bar, resplendent with decorative urns.

40
Springtime: Face à la Mer
1974
Acrylic on canvas
304.8 x 213.4
Private collection, London

41 [right]

Forecourt

1975

Acrylic on canvas

274.3 x 243.8

Private collection, UK

42 [opposite]

Entrance

1975

Acrylic on canvas

304.8 x 213.4

Private collection, USA

Entrance 1975 (fig.42), with its use of pergolas and trellis works against a wall, continues this more complicated treatment of interiors and exteriors. Given Caulfield's measured rate of production, in just two years he produced this and some of his largest and most complex and visually arresting canvases which also include *Paradise Bar* 1974 (fig.43) and *Forecourt* 1975 (fig.41). Once again the starting point for *Entrance* came from looking at travel brochures that depicted hotels, usually in Spain. In the foreground there were flowers collaged into the photograph that Caulfield speculated hid the dumper trucks in the process of building the hotel.[19] The contrast between what might be described as the picture's cheerful palette and an atmosphere of aloneness or *ennui* gives *Entrance*, like the best of Caulfield's paintings, its particular bittersweet tone.

5 CHICKEN KIEV BY CANDLELIGHT

IN THE MID-1970S Caulfield began to explore the language of painting, combining different styles of representation within the same work. He subverted the cool precision of his earlier paintings by inserting highly detailed realistic elements into the compositions, playing to great effect with ambiguous definitions of reality and artifice. If Caulfield's earlier work seems balanced between his use of the motif as painted by him and the image held in our minds that makes it recognisable, the incorporation of *trompe l'oeil* elements signals a move towards investigating different codes of representation. Conflicting possible readings are synthesised into what are, by any standard, exceptional paintings. These new works continued his focus on representations of objects that are generic in the sense that anyone can recognise them as an index of style and taste, but the challenge seems now to lead the viewer from their immediate response at the moment of encounter to a more detached perspective, from which it is possible to consider the implicit rules we use to decode and make sense of the conventions of painting.

Paradise Bar 1974 (fig.43) was the first work into which Caulfield introduced what he described as an 'alien style' to contrast incongruously with his own established style in the rest of the picture. He was prompted by a desire to disrupt the architectural settings which he had previously depicted in his

43
Paradise Bar
1974
Acrylic on canvas
274.3 x 213.4
Virginia Museum of Fine
Arts, Richmond. Sydney
and Frances Lewis
Contemporary Art Fund

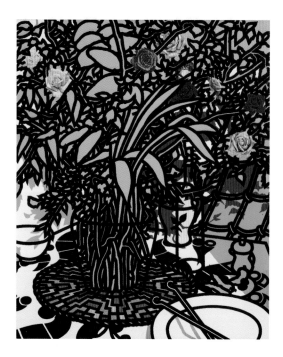

paradoxically anonymous style. In this instance the new and uncharacteristic element was a loose interpretation of a landscape mural which Caulfield had seen in an Indian restaurant in Westbourne Grove, London. In *Paradise Bar* the mural is rendered in vivid colours as a semi-abstract that is in jarring contrast to the rest of the interior which is in his established style. Caulfield has described how he imagined that the café interior had all the elements one would need in order to live a comfortable life, even extending to the credit card stickers on the window of the door, offering reassurance that one can 'pay later'. The door is deliberately left as raw or primed canvas which contrasts with the red warmth of the bar, suggesting as the artist described that 'there is nothing out there that you need – that everything is contained within this warm interior.'[1]

After completing *Paradise Bar*, Caulfield wanted to make another painting that would contain contrasting styles and techniques. Caulfield discovered in Chiswick a supplier of photo-murals and bought two, delighted by the supplier's comment that they were now 'out of fashion'. For *After Lunch* 1975 (fig.19) he chose the photo-mural of the Château de Chillon on Lake Geneva, his pleasure at its suitability being enhanced by the fact that it had so many associations, including the fact that Lord Byron had written a poem about it and that Courbet had painted several versions of the same view, with

44
Study of Roses
1976
Acrylic on canvas
91.5 x 76
David Roberts
Collection, London

Mont Blanc seen in the background. Caulfield's painting features a photo-realist image of the Château hanging in a restaurant interior that is depicted in simple black outlines against a flat, two-toned blue background. The scene takes place in the afternoon when the lights have been turned off; a waiter surveys the empty restaurant. The variation of tone contributes to the atmosphere of the scene by suggesting a shadow thrown across the imaginary space. In order to maintain the overall illusion of perspective in his painting, Caulfield cut the photo-mural so that it was not itself rectilinear and placed it at a height in the canvas such that the horizon in the photo-mural would be on the viewer's eye-line. He first attempted to cut and stick the mural directly onto the canvas but this did not work and it peeled off. Caulfield therefore decided to try to copy it accurately in paint – a technique he had not employed for about twenty years, when back in the mid-1950s he had briefly experimented with painting a few still lifes in a 'super-realist' manner. In *After Lunch*, as with many of Caulfield's larger scale paintings, a life-sized object is placed in the foreground, in this case a chair, in order to draw the viewer into the scene. The artist chose a style of cane chair, not usually found in restaurants, in order to allow a view through its structure. The inclusion of the goldfish bowl may echo a motif common to Matisse.

Caulfield was also keen to use various techniques within one work, which, in juxtaposition with his more schematic or formal style, interrogate the codes by which we perceive a painting as representing reality at all. This is not just a decoding of 'the language of painting', however; it is wider in scope and is part of an exploration the very act of perception and of representation. In this way his approach is perhaps closer to that of Magritte's examination of the very idea of representation as exemplified in his painting the *Treachery of Images* 1948 in which beneath an expertly rendered pipe are the words 'Ceci n'est pas un pipe' ('This is not a pipe'). Both artists' work is often laced with a subversive sense of humour through which they explore the process we use to decipher images. Works such as *Still Life: Mother's Day* 1975 (fig.22), *Entrance* 1975 (fig.42) and *Study of Roses* 1976 (fig.44) continue the interest in elements of *trompe l'oeil* realism. Caulfield's use of *trompe l'oeil* doesn't seek to confuse itself with the real but instead provokes a vertiginous and seductive hyperpresence of things that unsettles our sense of self and the real in a way that is more metaphysical than aesthetic.

In these paintings Caulfield's distinctive stylisation of black lines is juxtaposed with what appear to be superimposed, meticulously painted flower motifs.

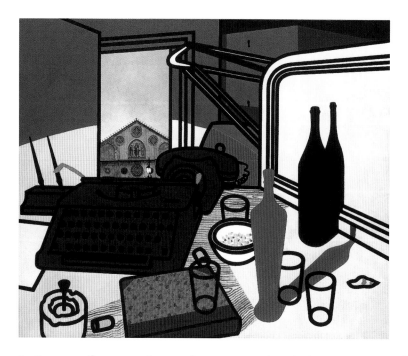

In *Entrance* flowers such as cyclamen, roses, hyacinths, anemones and lilies look as if they have been collaged directly onto the foliage outside the front of the building. The random placement of the flowers and their *trompe l'oeil* rendering is perturbing and ambiguous: their juxtaposition with the more formal style both heightens and undercuts their realism and they appear to float on the composition. Are they nothing other than self-referential elements of collage fixed onto the work or do they represent *really* real flowers? It is impossible to decide and the unsettling effect produced makes us question the codes of representation that we use to read a painting.

This unsettling effect is further reinforced by the highly saturated colour of the flowers which is akin to that of the rather crude colour reproductions on seed packets or plant catalogues that, one step removed, were used as source material. There is also a strange sense of juxtaposition in *Un gran bell'arrosto* 1977 (fig.21) where behind an excess of food spread out in a kitchen, a fountain is seen through the window. In contrast to the stylised interior the fountain is painted in a hyper-real style, its shape echoing the phallic form of many of the foods within so that a sense of fecund plenty is achieved.

Caulfield explored this use of juxtaposition fruitfully in other works. In *Office Party* 1977 (fig.45) and *After Work* 1977 he shows scenes that Hopper had

45
Office Party
1977
Acrylic on canvas
76.2 x 91.4
Clodagh and Leslie
Waddington

also depicted – the empty office after hours. Caulfield does not just suggest an atmosphere, unspecified menace or anxiety perhaps, but also deploys formal contrasts again. In *Office Party* a hyper-realist image of Spoleto Cathedral is spied through the window and in *After Work* it is the view from the window that contrasts with the usual black outlined interior: this time the exterior is not realistically rendered but a lighter, sketchier style suggests the urban skyline.

Caulfield's most audacious use of this style is perhaps *Unfinished Painting* 1978. The work is in fact finished but it shows us a kitchen interior, again with *trompe l'oeil* elements (the slice of pie, the glass etc.), where the borders of the work are shown as 'unfinished'. The juxtaposition here is between the finished central portion and the deliberate depiction of a work in progress. We can see how the effect of realistic portrayal is being constructed but the title suggests that this is almost incidental: what is being displayed is a painting of an unfinished painting. A complex and ambiguous response is elicited that raises and explores questions of perception which, for Caulfield, is never a simple registering of an external world but is structured by emotion and cultural expectation. It also highlights one of the artist's perennial concerns: the artifice of the world that surrounded him and the cornucopia of simulacra. Using borrowed styles and appropriated images he sought to describe the world in which he lived, to record its idiosyncrasies, to isolate and paint that which made it unique. Caulfield explained:

> The reason I did the painting is that various artists were showing paintings that were unfinished. It gave me the idea to do a painting which was finished but which was called 'unfinished.' It looks like a sampler of how to do a painting but is, of course, not so … It was an idea of peripheral vision, so that the central photographic area which is focused on is surrounded by form and colour, which becomes more abstract and less easy to sum up around the edge.[2]

In the painting *Town and Country* 1979 (fig.46), Caulfield's first large interior since 1975, matters are complicated further. A dizzying variety of 1960s patterned surfaces decorate the corner space of a hotel foyer. The undulating lines of the wallpaper pattern are a theme that came to dominate Caulfield's work of the late 1970s. Widely contrasting with the *trompe l'oeil* wood-grain surfaces, these competing patterns articulate oblique angles that are in part shaped by the filter of carefully choreographed light and shade.

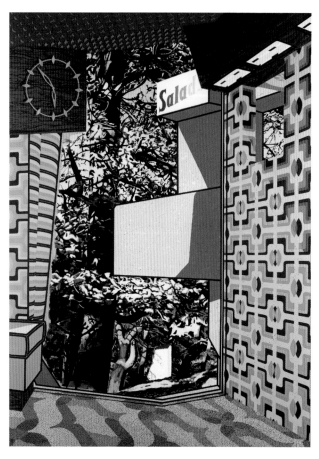

A clock points to cocktail time and to its right a sign reads 'Salads', which is perhaps part of an advertisement for meals available inside. Through a small window on the right-hand side, one can see the carefully rendered branches and leaves of a forest, the imagery taken from a colour photograph in an advertisement. Caulfield commented: 'I didn't blow it up or anything. I painted it somewhat loosely, sometimes looking at it through a magnifying glass, looking at the strokes and trying to make similar strokes. I don't see it as photographically painted, though it does come across as having a photographic source.'[3] He also said, 'I think of this area as a very cardboard Marie Antoinette idea of rusticity' and described his intent on being 'in contrast to this unlikely modern interior, to point up the idea of town and country, the artificiality of the view of the country.'[4]

Caulfield's comments make clear that this use of contrasting elements and styles is not purely formal but is entangled with the subject matter itself,

46
Town and Country
1979
Acrylic on canvas
231.1 x 165.1
Private collection, London

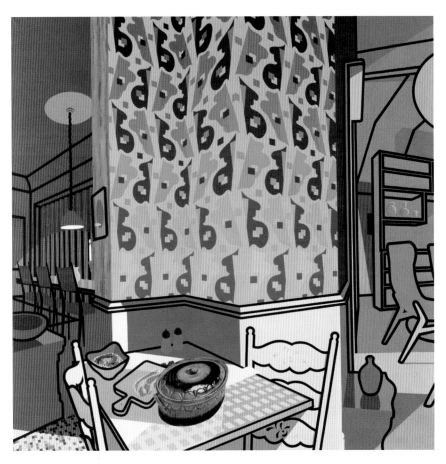

47
Dining/Kitchen/Living
1980
Acrylic on canvas
179.1 x 179.1
Tochigi Prefectural
Museum of Fine Arts

in this case a contrast between urban and rural and how the country is seen from the perspective of the city dweller. The style of these paintings draws attention to the objects themselves and their wider resonance. Caulfield explained:

> I find that in treating different things in different ways, they become a point of focus. It's the idea that one doesn't encompass everything, and that your eye can look around and see things. I'm not sure whether it's your eye or whether it's that your memory remembers things in different ways. There seems to be no reason to treat everything evenly. It's more like a collaged memory of things. Some of the things are in sharp focus, and others, if you like, symbolise the object.[5]

Dining/Kitchen/Living 1980 (fig.47) continues Caulfield's experimentation with pictorial language where once again he inserts an element of *trompe l'oeil*

– in this instance his family's casserole. One of Caulfield's most impressive achievements is his ability to convey direct and immediate images through such a sophisticated use of colour and line. The bold and assured graphic appearance of his paintings belies the subtle stylistic complexity of his subject matter. The use of *trompe l'oeil* and his very particular colour palette leads to the question of how far Caulfield is engaging with kitsch. This is not to say that Caulfield's work is itself kitsch but, rather, that his hyper-realist portrayal of everyday objects (often as generic types mediated by mass media) paradoxically foregrounds their artificiality and could be read as a comment on the inherently kitsch nature of such representations. This combination of styles and the subject matter itself mixes high art and low or kitsch art with a cool eye that refuses to either valorise or denigrate one element or the other. The lovingly detailed advertisement-style rendering of a chicken Kiev or a bowl of mussels, the carefully depicted William Morris wallpaper, the fondue dish, Victorian oil lamp or office paraphernalia all reflect his interest in the mundane or the ordinary. There is no snobbishness in his choice. Just as in his early painting *Sculpture in a Landscape* 1966, which depicts a modern Barbara Hepworth-like sculpture placed in an anonymous landscape, a sense of irony towards the topic is often tempered by a sense of humour and affection. He neither uncritically champions popular culture like the Independent Group or some of the pop artists nor retreats to a high art position that could not truly represent the contemporary world. Caulfield thus remains true to his vocation as a painter of modern life; his pictures refuse judgement but reveal a concern with the everyday that makes visible its enigmatic core.

In 1979 the family moved to one of twelve nineteenth-century, purpose-built artist studios in Primrose Hill, north-west London. His friend John Hoyland was one of their new neighbours and when Hoyland was invited to be artist-in-residence at Melbourne University, Australia, Caulfield joined him for five weeks at the beginning of 1980. En route to Australia, Caulfield and Hoyland visited Mumbai. The painting *Still Life: Maroochydore* 1980–81 (fig.33) is in part based on a postcard bought during his trip to Australia. The landscape in the painting is actually a view of the River Seine taken from a black and white postcard but the colour palette he used is closer to the postcard of Maroochydore.

Still Life: Maroochydore uses a plethora of styles. This visual richness matches the richness of the subject matter in which a number of different

Les Beignets de Langoustines

La Fondue Bourguignonne

Les Moules "Marinière"

Les Escargots de Bourgogne

48
A selection of French recipe cards used as source material by Caulfield

foods are laid out before us. The cornucopia of food suggests a very immediate and physical hedonism and this sense of pleasure is reinforced by the landscape, which has the air of holiday idyll. The riot of styles is an index of techniques that Caulfield had previously used: the *trompe l'oeil* plate and wood-grain, the collage-like geometric tablecloth and tiling, the familiar black line rendering of some of the objects, the looser rendering of the landscape and heightened colours of the food. As well as the landscape, the plates of food were also drawn from photographic sources: a collection of French recipe cards (fig.48). Similarly, the picture also uses a number of Caulfield's recurrent motifs: food, everyday objects, an interior with a window allowing a view of a landscape. That this variety of form and content still retains an overall integrity is a testament to Caulfield's mastery.

The picture toys with kitsch in its very richness; there is almost too much on offer. Despite this, there is no feeling that Caulfield is trying to expose a vulgar petit bourgeois fantasy and the promise of pleasure seems very real. The overwhelming visual surfeit perhaps serves to undercut the message of promised enjoyment but this serves not as some form of critique rather as a rueful acknowledgement of the transience of pleasure, a melancholic recognition of the human condition.

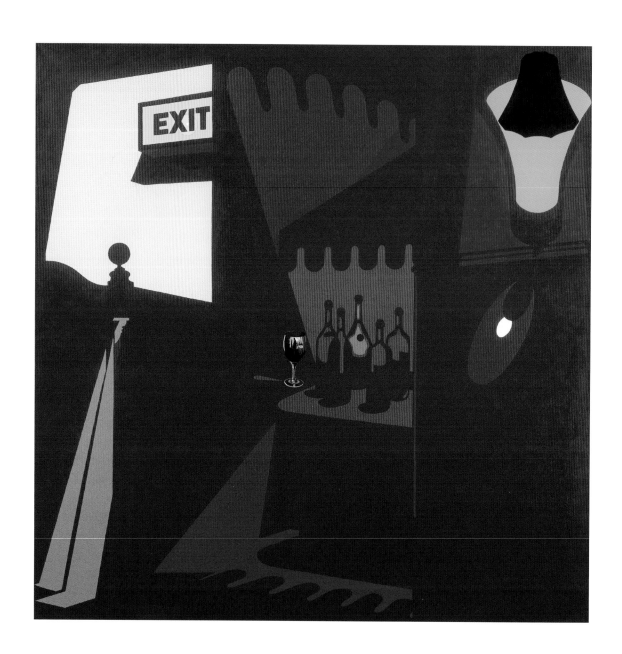

49
Happy Hour
1996
Acrylic on canvas
193 x 193
Private collection, London

6 THE FRIENDSHIP OF HOTEL ROOMS

CAULFIELD WAS ALWAYS a keen reader. He liked American literature, for example John Steinbeck, William Faulkner and Ernest Hemingway, as well as biographies and books on military history. In the 1980s he was introduced to the poetry and prose of Raymond Carver, whose sparse dramas of loneliness, despair and troubled relationships breathed new life into the American short story of the 1970s and 1980s. Suggestive rather than explicit, and seeming all the more powerful for what is left unsaid, Carver's pared-down style of writing appealed to Caulfield. He wrote with unflinching exactness about issues of loss and lives, often on the knife-edge of poverty and shadowed by alcoholism, which are undercurrents for his characters' mundane lives. Carver's fictions, in a similar way to Hopper's paintings, capture the pensive nuances of life within the seedy architecture of diners and motel rooms. When Carver visited Britain in 1986 shortly before his own premature death, Caulfield, who was unwell at the time, crossed London to hear him read at the Poetry Society in Earl's Court Square.

On the window beside the door in his studio in Archer Street he stencilled 'Sam Spade', the name of the private detective who is the protagonist of Dashiell Hammett's 1930 novel *The Maltese Falcon*. Spade is the archetypal

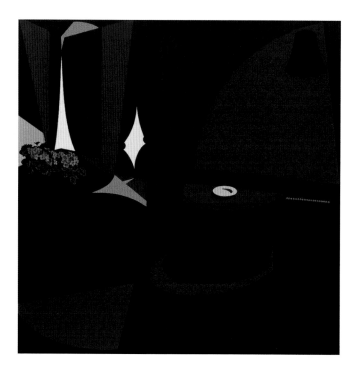

film-noir detective who was a precursor of Raymond Chandler's character Philip Marlowe – also a favourite of Caulfield's. Caulfield enjoyed the sense of romantic melancholy in *Casablanca* and *To Have and Have Not* and Westerns such as *She Wore a Yellow Ribbon* but the themes of film noir, namely the fragile nature of the human condition, were especially appealing. These films are known for their very theatrical set pieces, stark contrast of light and shade, low and wide-angle shots and the use of mirrors and oddly highlighted objects and faces. While Caulfield's paintings use a different register – there is no suggestion of the use of crime narrative – this has obvious resonance with his approach to image making. Caulfield described:

> I think an artist will inevitably begin with a lot of enthusiasm for his early influences and hope that these are not diluted. But life's experiences inevitably take over and many other things, whether clear or half-remembered, mould your work. These are not always connected with your own medium. In my case, I find the cinema a continuing influence, particularly the lighting in black and white films, and especially in film noir. One of my favourite films in this genre is Orson Welles's *Touch of Evil*. Unfortunately, the melodrama of the lighting is as far as I can follow in my own work.[1]

50

Rust Never Sleeps

1996

Acrylic on canvas

193 x 193

Destroyed in warehouse fire, 2004. Formerly Saatchi Gallery, London

Many of Caulfield's paintings seem to have a sense of stillness or calm. There is a sense of overwhelming silence and yet they seem to be about time: the hiatus or gap between significant moments. Pared down to the essentials of the scene, the atmosphere in works such as the dark red and brown interior of *Rust Never Sleeps* 1996 (fig.50) or *Happy Hour* 1996 (fig.49) increasingly appear to be like sets without the actors: the telephone about to ring, a drama about to unfold, or just ended. This is in part due to the sense of depth created through his depiction of deep, raking shadows. Although his interiors are missing the human protagonist, Caulfield provides just enough visual information to create a strong sense that human presence is never far away. This corresponds with his fascination with restaurants and hotel lobbies – they are potentially dramatic sets, places of transient meetings and encounters. Almost non-places, they are zones of transit set aside from routine work that imply leisure, liasons or the possibility of dramatic action.

Rust Never Sleeps depicts the shadowy corner of a club or bar. The scene is suggested by a series of almost abstract forms that are arranged on a flat, brown field. The vivid red of the table, the wall behind the table and part of the floor are quadrants of a circle, with the table and wall having a minimal amount of detailing to enable us to decipher what they are. Panelling is suggested by a wood grain effect and the curtained windows by stark triangles and rectangular forms. The most striking effect is the *trompe l'oeil* potted flowers, odd enough in contrast to the surrounding schematic forms, which seems to float on the brown background. A single leg obtruding into the splash of red floor and the angle the brown makes with the window recess are just enough to suggest a table on which the flowers rest. The life-sized canvas invites us to step inside and occupy the set but the picture is equivocal in the response it elicits: it offers the promise of a cosy corner in which to while away time drinking but the depth of the brown suggests an almost stygian gloom that threatens to swallow us and the vividness of the red flags danger. The title itself, *Rust Never Sleeps*, warns of the inevitability of slow decay and perhaps suggests that time here will be merely time in the passage towards a common mortality.[2]

In *Happy Hour* the space is modeled from abstract forms. Shadows become objects while objects morph into the shadows. At the centre of the picture, five wine bottles cast shadows from a mysterious light source in the empty bar. Next to the bottles, a glass of red wine is suspended. Rendered in a photorealist manner the convex surface of the wine glass contains a reflection of Caulfield himself. On the right hand side a black lamp is superimposed

over an inverted light source while on the left, framed by a window-shaped white light, an EXIT sign, like an ironic modern day *momento mori* reminds us of the brevity of life. In *Hotel Room* 2000 a flat field of deep brown predominates. To the extreme right we see the edge and keyhole of the hotel door that stands ajar; the viewer is standing on the threshold of the hotel room. The schematic presentation of the room's contents uses clearly delineated shapes to suggest the sculptural form of the room's contents: a table, a lamp, the headboard of a bed, a picture on the wall. These fixtures are anonymous and generic, even the picture on the wall is a minimal arrangement of dots. This bland view is relieved by the warm pink splash of light from a window and the deeper pink of the petunias on the table. The flowers are rendered in incongruous *trompe l'oeil* with the otherwise bland interior. It may appear at first that the light from the window and the flowers are suggesting that the real world lies outside and that we are entering a space removed from warmth and nature but overall the room appears inviting. The brown has a chocolate warmth that seems to invite repose and quiet thought. The flowers represent not Nature but the idea of nature, artfully placed to give focus to the room. The room is more than the sum of its parts and the final impression is one of undecidability of mood – it suggests both melancholy loneliness and a potential meditative refuge from the world outside. In a work such as *Hotel Room* a sense of the forlorn or melancholy is counterbalanced by an understanding of the potential richness of things that harks back to Laforgue's line 'I've only the friendship of hotel rooms.'

In 1986 Caulfield was invited by the National Gallery, London to curate *The Artist's Eye*. This was the seventh in a series of exhibitions where distinguished artists were invited to select works from the holdings of the National Gallery. Unlike previous selectors, including Anthony Caro and Francis Bacon, who had focused on 'masterpieces', Caulfield brought together relatively unknown works from a broad range of genres that reflected his interest in light and offered an insight into some underlying relationships between Caulfield's paintings and the works chosen. As John McEwen noted in the booklet which accompanied the show, 'The Dutch arguably have proved themselves the most masterful painters of still lifes and architectural scenes, and considering Caulfield's own exploration of these themes in his own paintings, it is not surprising that Dutch painters figured so largely in his choice.'[3]

Caulfield chose elements from two paintings by Pieter de Hooch (1629–84) with which to illustrate the exhibition poster. *The Courtyard of a House in*

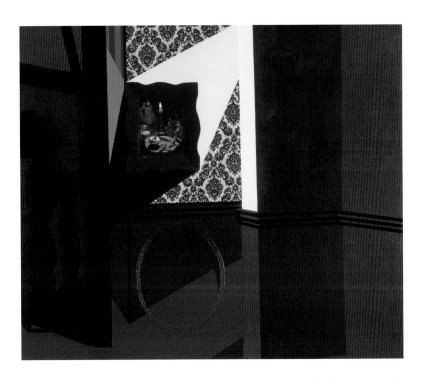

51
Interior with a Picture
1985–6
Acrylic on canvas
205.8 x 244.2
Tate. Accepted by HM
Government in lieu of
tax and allocated to the
Tate Gallery 1996

Delft 1658 and *A Musical Party in a Courtyard* 1677 both focus on domestic settings looking through to a distant view that acts as a spatial counterpoint and second area of focus to the scene in the foreground. As Caulfield makes clear:

> The midday scene comes from the upstairs galleries, the evening one from the basement, but they make a wonderful pair because compositionally they have the same elements in reverse: an archway framing deep space on one side with a mysterious silhouetted figure standing there, and two or more figures in conversation off-setting it in shallow space on the other side. One is a rather dry domestic setting; the other is highly charged, with its romantic flaming sunset. It's nearly cinematic, this particular painting, with its drama.[4]

Two of his own paintings, *Lunchtime* 1985, which shows a corner of a pub or tavern decorated with a pot of geraniums and *Interior with a Picture* 1985–6 (fig.51), were also included in the exhibition. Caulfield said that *Lunchtime* 'meant to represent the feeling of a time of day rather than anything specifically to do with lunch. There is the artificial light given off by the lamps, and daylight is a band across the floor. I suppose it reflects my interest in urban imagery, which tends to take the form, for me, of restaurants and

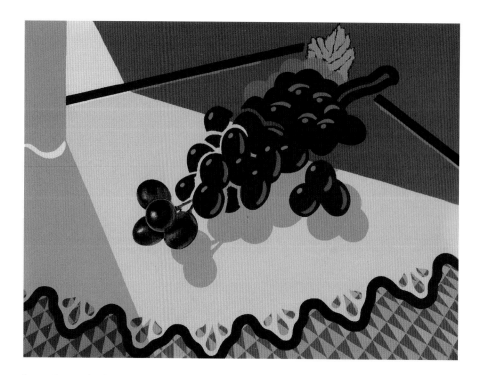

bars.'⁵ On the basis of his selection, Caulfield was short-listed for the Turner Prize, where along with *Interior with a Picture*, he exhibited *Buffet* 1987 with its hyper-real fruit against a brown ground. This was the first major painting in which he did not use the characteristic black line. The decision to simplify his compositions and to dispense completely with the outline was the result of a feeling that it was time to reinvent the terms of his art. This was triggered by the artist's concern about being typecast by the descriptive black outline that for so long had been a vital element of his signature style. As early as *Selected Grapes* 1981 (fig.52) he had stopped using the line as a means with which to help describe three-dimensional forms on a flat surface but rather used it only to establish the sense of the corner of the table and the frilly edge of the cloth. The grapes themselves and their cast shadows are painted as flat patches of colour with simple highlights, and in works such as *Candle-lit Dinner* 1981–2 (fig.53) some of the objects such as the candlestick holder have thick black outlines and flat colour, but the chicken Kievs and bunch of flowers are executed more realistically.

In the summer of 1989 Caulfield had a solo exhibition of paintings at Waddington Galleries. The show included large canvases such as *Buffet* and the closely related *Reception* of 1988 which consisted of simplified elements,

52

Selected Grapes

1981

Acrylic and oil on canvas

45.7 x 60.8

British Council Collection

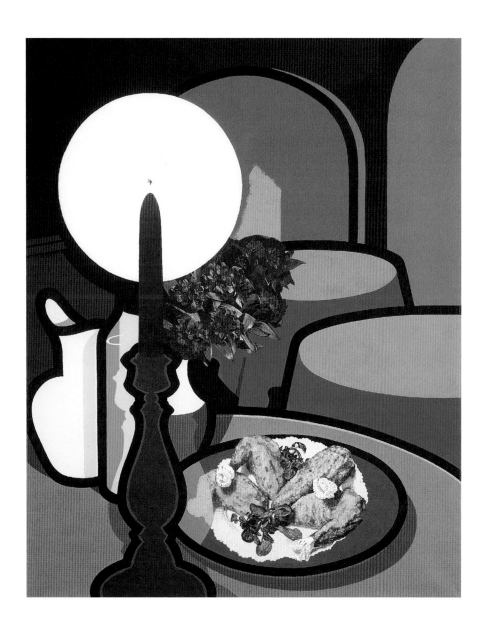

53
Candle-lit Dinner
1981–2
Acrylic on canvas
76.2 x 61
Private collection, London

including lamp shades and richly decorative pots or plates, combined with floral photorealist elements, floating on flat planes of colour. For these works Caulfield used a different compositional process than hitherto. During the 1960s and 1970s Caulfield had planned his paintings carefully in advance. Composition and details were established in preliminary sketches which led on to a final drawing that was then squared up and vertically indexed by numbers and horizontally by letters. Using felt tip this would have been transferred into its final scale on a similarly squared-up piece of polythene. Then, after applying a basic ground colour to the canvas, the polythene could be overlaid and the image traced directly onto it. However over time Caulfield moved away from painting a single image. This gradually prompted a different way of working so that by the late 1980s formal decisions were no longer rigidly worked out in advance but became more about a process of combining two or three elements or styles that were chosen intuitively, 'rather like putting a jigsaw together, adding elements until the canvas becomes a whole.'[6]

His sketchbooks highlight how preliminary drawings were important to Caulfield's practice as an artist. Since his student days he kept a sketchbook which was randomly used as an *aide-mémoire* – a means to capture the immediate or the contingent or to resolve basic compositional issues so essential to the impression his paintings conveyed of having arrived effortlessly. Mainly executed in pencil, the drawings range from pictorial notes or schematic diagrams on composition format and spatial logic, or the optical effect of one colour against another, to close observations of objects or staged props. These sketches of various elements for the painting, or on occasion the whole composition, were then used as guidelines before he embarked on the detailed drawings that drew on various sources including illustrations he found in books, magazines or brochures.[7] As such they offered Caulfield the opportunity to resolve the arrangement of his carefully constructed interiors as well as the chance to explore radical lighting effects, for example, the way a shaft of light falls through a window to animate a wine glass or vase, or spills out from a lantern. The sketchbooks detail how light increasingly was to become an important expressive force. Caulfield's depiction of it frequently appears as a geometric form, taking the shape of a rectangle, parallelogram, rhomboid or trapezoid that habitually invokes a window or door. These abstract forms of light were to become carefully positioned painted presences in the interlocking geometric architectural elements of rooms and buildings through or on which they shine and which, in turn, define the shape and form of those reflections.

During the late 1980s Caulfield's use of colour strengthened further – canary yellow, bright pink, pea green – all of which helped do away with the need for outlines. Both *Buffet* 1987 and *Reception* 1988 utilise a similar approach, combining photorealist motifs within the context of a more formal style that almost approaches abstraction. Compared with the complex level of detail which fills every area of his works from the late 1970s and early 1980s these paintings are radically simplified with a small number of elements convened on a dominating background field that is largely empty. In *Buffet* the ground is, unusually, textured while in *Reception* the canvas is a uniform bright yellow. Both works feature the dark shape of a lamp-shade, a recurrent Caulfield motif. *Buffet* features two circles of light (one slightly elongated) thrown by the lamp. An oblong of a darker yellow and a smaller circle are cryptic: they may be splashes of light from windows or other lights. The circular forms are echoed by a disc of blue and a plate in the top left-hand corner. The plate and a display of fruit are rendered in a photorealist style, to which the viewer is inevitably drawn, mimicking the selective nature of perception in which the eye is directed to a focal point with peripheral vision reduced to a schematic impression. *Reception* is even more stripped down: a hard-edged shape represents the light from the lamp, a large and small circle of black float on the ground and, again, there are two photorealist elements – a spray of flowers and the willow-patterned lampstand. There is the same concern with the nature of perception but, in both works, it is pushed to almost parodic extremes in the contrast of minimal background and overly detailed realist objects.

In *The Blue Posts* 1989 the strategic placement of a few key shapes and shadows transforms an ostensibly abstract picture into a work that conjures up a sense of place. The title refers to a public house of that name close to Caulfield's studio. The suggestion of colour and object in the title appealed to the artist in that they are absent from the painting, which, however, still retains a visual association with the place itself. As is always the case, the painting is an analogy of a place constructed from various other sources and memories. In smaller paintings such as *Patio* 1988 areas are covered with thick paint combed to imitate actual surface textures of bogus plasterwork such as artex-like impasto or anaglypta and other lodging-house surfaces that extended his interest in the everyday banal. In other works like *Grill* 1988 he started squeezing acrylic paint straight out of the tube on to the surface of the picture and yet his use of impasto or different kinds of brushstroke are always a logical part of the image. This adding of texture or collage to his paintings

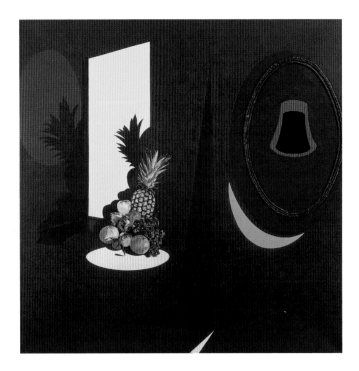

continued in the early 1990s in paintings which extended Caulfield's familiar
repertoire of drinking glasses, lampshades, shafts of light and crisp shadows,
and in the small collage-like pipe paintings on canvas and board that were
themselves a nod to Magritte. Shortly after this Caulfield returned to working
with a square format. *Room* 1995, *Fruit Display* 1996 (fig.54) and *Registry
Office* 1997 (fig.55) all contain objects shaped from light and embellished by
shadows, mixed with photorealist elements that float on planes of colour. This
sense of focused light is also explored in a work such as *The Register* 1993
where he sets himself the challenge of depicting an interior space and creating
depth primarily through the shadows of objects and language of shapes one
may associate with a generic hotel reception.

Caulfield's second painting retrospective opened at the Serpentine Galley,
London, in November 1992. Included in the hang was *Portrait of Juan Gris*
(fig.14), his tribute to the cubist painter and it was a happy coincidence that the
exhibition dates crossed over with the Gris retrospective at the Whitechapel
Art Gallery. Caulfield's attachment to early twentieth-century European
painting never waned and five years later he enjoyed visiting *Braque: The
Late Works* at the Royal Academy, which highlighted Braque's lifelong
interest in the depiction of interior and exterior space and the relationship of

54
Fruit Display
1996
Acrylic on canvas
193.4 x 193.4
Waddington Custot Galleries

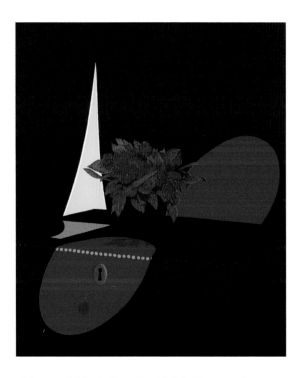

55
Registry Office
1997
Acrylic on canvas
92.1 x 76.8
Arts Council Collection,
Southbank Centre, London

objects within it. For Caulfield, Georges Braque continued to be a 'source of inspiration' but this was tempered by a feeling that 'his way of working was so personal and free that one couldn't take anything from it' whereas Gris's formalism was more 'accessible'.[8] Nonetheless Caulfield's appreciation of the complexities of cubism and, in particular, of Braque's interiors of the mid-1930s and his use of the decorative as a way of freeing colour from form is evident in Caulfield's return to ornamentation towards the end of his life.

The 1990s saw Caulfield's contribution to British art being officially acknowledged: he was elected a Royal Academician and made a Senior Fellow of the Royal College of Art, shared the Jerwood Painting Prize with Maggi Hambling and in 1996 he received a CBE. Other honours included an Honorary Fellowship from Bolton Institute of Higher Education (now University of Bolton) in 1999 and an Honorary Doctorate from the University of Portsmouth in 2002. Caulfield's third painting retrospective opened at the Hayward Gallery, London, in February 1999. Jointly organised by the Hayward Gallery and the British Council, it subsequently toured to Europe and the USA. To coincide with the retrospective the Alan Cristea Gallery organised an exhibition of prints and published a catalogue raisonné of the complete prints 1964–99. Cristea had been involved with the

publishing of Caulfield's prints since the early 1970s, firstly as an employee of The Waddington Galleries and subsequently under the aegis of his own gallery. The final print in the exhibition, *Les Demoiselles d'Avignon vues de Derrière* 1999, was based on Picasso's famously confrontational painting depicting prostitutes, *Les Demoiselles d'Avignon* 1907, which marks the beginning of cubism. Caulfield has reversed Picasso's image so that instead of viewing the women frontally, we peer at them from behind. The reversal of this image is both a visual pun on the printing process, which reverses the original design, and a verbal pun on the French word *derrière*, which means rear end. In the autumn Caulfield married Janet Nathan. He was also one of three artists commissioned to design a poster to celebrate the re-opening of the Royal Opera House after major renovation. This was not the first time Caulfield had been asked to collaborate with a project for the Opera House: in 1984 he had been commissioned to design the set and costumes for Michael Corder's ballet *Party Games* and again in 1995 for Sir Frederick Ashton's penultimate work *Rhapsody*.

Throughout his career Caulfield enjoyed the challenges and variety of commissions. Early on he produced twenty-two screenprints for a limited edition book, *Some Poems of Jules Laforgue* (fig.18), and in 1975 he made *Pool*, his first wall hanging for his show at The Waddington Galleries. This was followed in 1982 by *The London Life Mural* measuring 6 x 6 metres for the entrance hall of the London Life Insurance Company in Bristol. In the early 1990s he designed a stained-glass window, *Paper Moon*, for a re-launch of The Ivy, a well-known London restaurant (and favourite of Caulfield's), and the following year a 12 x 12 metre carpet for the atrium of the British Council building in Manchester, the design for which was inspired by Celtic symbolism. He was also commissioned to design a mosaic for the National Museum in Cardiff to occupy the rotunda in the museum's new extension. *Flowers, Lily Pad and Labels* refers to the three water lily paintings by Monet in the permanent collection and also to an early painting Caulfield had made of the subject matter in 1968. Other commissions include the design for the decoration of the Members' Room at the Royal Academy of Arts and a mosaic for Arco di Travertino Station on the Rome Metro, the new doors for the West Organ at Portsmouth Cathedral, all in 2001, and *Pause on the Landing* 1994–2006 (fig.56), a 4.5 metre tapestry for the British Library at St Pancras, London based on a theme from the eccentric family saga *The Life and Opinions of Tristram Shandy, Gentleman* by Laurence Sterne, one of Caulfield's favourite books.

56
Pause on the Landing
1994–2006
Wool tapestry
290 x 414.2
British Library, London

The tapestry depicts a comic episode in which Tristram's father, Walter Shandy, and his Uncle Toby, engrossed in conversation on their way down a flight of stairs, pause for a time on the landing as they descend from the bedroom where Mr Shandy has been bemoaning the damage done to his son's nose during birth. On several occasions Walter extends his foot on to the next step down, only to withdraw it each time he warms to his next topic of conversation. Specific elements from the book's comic narrative are explored in the tapestry design: the grey striped areas are both the staircase on which they stand and plan views of possible military fortifications; the pink triangle on the left references Tristram's nose; the shape in the centre represents Uncle Toby's crutch, with which he accidentally hits Walter Shandy's leg as they converse on the landing; and the clock on the right refers to the moment during Tristram's conception when his mother asks his father 'Pray, my dear … have you not forgot to wind up the clock?' (the red circle is the keyhole to the winding mechanism). The clock, a symbol and measure of the passing of time, has a central role in *Tristram Shandy* that is echoed in Caulfield's tapestry. Underlying the comedy is an awareness of the brevity of life which we must live to the full.

57
Hemingway Never Ate Here
1999
Acrylic and rope on canvas
213.8 x 191.1
Tate. Purchased 1999

7 LIGHT AND SHADE

MANY OF CAULFIELD'S interior scenes play with methods of portraying different forms, combinations and sources of light. Having painted initially in a flat, linear mode he became increasingly aware of how he could create areas of shadow and differentiations of light intensity by the simple device of contrasting pure colour with no tonal interplay, so that their sharp and seemingly arbitrary divisions cut into and across the picture plane. In Caulfield's mature work his understanding of the ways in which light defines space and colour and how it can also suggest depth of field allowed for a more sculptural interpretation of pictorial space that extends back to his interest in Hopper. The world is presented as a pattern of overlapping fragments or planes among which appear hints and allusions to reality. *After Lunch* 1975 (fig.19) is an example of the initial approach Caulfield made in handling light: a sharp-edged band of pale blue cuts across the deeper blue of the rest of the painting (save for the *trompe l'oeil* mural), depicting the afternoon sunlight cutting across the restaurant. By the 1980s works such as *Green Drink* 1984 (fig.30) used the complex geometry of the painting's elements to suggest a more subtle play of light which, through the 1990s became more pronounced and suggestive of depth to the picture plane. In *Rust Never Sleeps* 1996 (fig.50), for instance, the use of light and dark to suggest palpable three-dimensionality is masterfully handled. In the painting *Hedone* 1996, which takes the name

of a villa in Pompeii the artist visited the same year, the walls seem to be illuminated by intense Mediterranean light as well as by a lamp positioned in the top right hand corner. There are shafts and pools of light and decorative or descriptive shadows. On a shelf is a carefully rendered still life of uncooked steaks. In discussing this work Caulfield explained how, halfway through working, he realised that the subject matter of this painting was really about a two-tone wall which reminded him of his visit to the panelled Roman frescos earlier that year and how the Pompeii wall paintings create an illusion of a three dimensional space which guides the viewer's eye towards imaginary scenes often framed by painted columns and other architectural elements.

Examining in detail a painting such as *Interior with a Picture* 1985 (fig.51), we can see the way Caulfield used light not merely for realistic effect but as an integral part of the totality of the work. This work also incorporates *trompe l'oeil* and photorealistic elements in order to playfully explore the relationship between notions of reality, artifice and illusion. This large oil painting shows a domestic interior but instead of choosing a traditional view of a dining or sitting room it focuses on a confined area that is the junction between a landing and two corridors (a subject that reoccurs in *Pause on the Landing* 1996–2005 (fig.56), the tapestry for the British Library). For most of the picture Caulfield uses flat blocks of colour to suggest form and space. The juxtaposition of these two styles contributes to the uncertainty surrounding the relationship of the staircase to the rest of the interior, the position of the still-life painting (a picture-within-a-picture) in relation to the wall and the precise arrangement of the floor level. The scene in the picture-within-a-picture is in this instance a careful copy of the still life *Meal by Candlelight* by the German artist Gottfried von Wedig (1583–1641) which Caulfield had found in Charles Sterling's book *Still Life Painting from Antiquity to the Present Time*.[1] The composition features a burning candle, which provides the only source of light in the picture. The lid of the salt box is open and a crust of bread is sticking out of the eggshell. Caulfield enlarged the book illustration of von Wedig's picture to approximately the same size as the original and then painted a modern frame around it. This interior also plays with methods of portraying different forms, combinations and sources of light, a theme that would become even more prominent in later work. The flat yellow shaft of light that illuminates the painting contrasts with the subtle modulations of candlelight within the still life itself. The black descriptive line, which had been the primary means of defining form and space in earlier paintings, is used sparingly here so that only the corner of the

58
Reserved Table
2000
Acrylic on canvas
183 x 190
Pallant House Gallery,
Chichester (Wilson Gift
through The Art Fund, 2006)

corridor in this imagined space, the dado-rail and the banister are described by a black line. Directly below the painting is an oval motif formed from three thick strands of acrylic paint squeezed from the paint tube onto the canvas. The dialogue between two dimensional, naturalistic representation and three-dimensional reality again highlights Caulfield's interest in the artifice of painting. Because of the abstracted style used for the setting, the painting appears more 'real' than the space within which it hangs. As Caulfield put it:

> The spaces and interiors we see in real life are always more surprising than those we could invent. Since one can't actually compete with the unexpectedness of reality, I feel free to invent any contortions of space as long as they work for me. At the same time I don't want to do something which is so artificial that it becomes surrealism. I want it to have some link with reality.[2]

Caulfield's ambition to strike the balance between reality and artifice is further highlighted by a works such as *Hemingway Never Ate Here* 1999 (fig.57) and *Reserved Table* 2000 (fig.58) with its giant lobster. *Hemingway Never Ate Here* received its first public showing in the exhibition

Encounters: New Art from Old at the National Gallery in 2000, in which twenty-four artists were invited to make work in response to paintings in the gallery's collection. The interior is based on a Spanish theme and the title taken from a text on the awning of a restaurant in Madrid that Caulfield had visited in 1998. Though Caulfield had always admired Spanish still life paintings his choice was partly determined by his wish to celebrate the marriage of his eldest son Luke to a Spaniard. The painting, set in a highly abstracted imaginary Spanish restaurant, juxtaposes a *trompe l'oeil* stuffed bull's head with a bottle of lager and a white cup on a pewter dish – a detail borrowed by the artist from a painting by Francisco de Zurbarán (1598–1664), *A Cup of Water and a Rose on a Silver Plate* c.1630. The bull's head was painted from a stuffed head that Caulfield hired for this purpose.

59
Bishops
2004
Acrylic on canvas
213.4 x 198.1
Private collection, London

Here the emphasis is on intervals between one type of image and another, between the literal and the suggested. Much has been made of Caulfield as a brilliant colourist bringing a peculiarly English sensibility to the mélange of art history, but for Caulfield the subject of painting was in many ways painting itself, and the problems he set himself were concerned with creating space and illusion on a flat surface. And yet light in all its permutations undoubtedly is the main preoccupation of Caulfield's late work. The paintings radiate a complex sense of space, of mood – and a love of detail. He has described how in these works he painted shadows in two ways – firstly as if real tonal shadows, realistic to the point of defining the object and secondly as a decorative or metaphorical device. What is striking about these paintings is Caulfield's ability to extract every nuance out of an essentially tonal palette – a palette that, with occasional recourse to more emphatic colour, defines these works and the sombre poetic emotion they convey. In keeping with his own particular vision Caulfield sought to describe the world in which he lived, to record its idiosyncrasies, doing so with a sense of mystery and not the slightest trace of sentimentality.

While the elements in a picture such as *Bishops* 2004 (fig.59) may appear in strange and unexpected juxtapositions, the logic of normal spatial relationships is still observed. 'I like very structured painting', Caulfield said.[3] 'I simply try to make a logical, a seemingly logical, space that could exist.'[4] *Bishops* was painted in 2004 when Caulfield was already increasingly incapacitated by cancer. In the painting the swing doors are slightly ajar as if someone has just entered or left the room, but they remain unseen. Behind the doors a large yellow lamp shade hovers as if suspended in space. In the lobby, which suggests a hotel, all is shadowy calm, a network of sombre but warm mauves and purples. The chair is an exception, being a rich brown, and its surface shares the artex patterning of the wall against which it stands as if it were part of the very fabric of the building. The blocks of colour suggest the complex interplay of light while to the centre, at the rear of the lobby, a passage leads into the darker shadows of the building's interior which seems to invite us to enter further. Is the building indeed a hotel? What does the cryptic title *Bishops* refer to? The name of the building, perhaps, or a reference to the episcopal purples? Who has entered or exited the building and to what purpose? Have they left to enter the hubbub of the world beyond the painting or retreated into its restful depths? There are no answers: the picture has something of the character of a puzzle or game and also something of the character of poetry – presenting an image of the world that is meditative, haunting, lyrical, mysterious and sometimes obscure.

Braque Curtain 2005 (fig.60) was Caulfield's last painting and work on it occupied him during the final year of his life. On his death, books containing reproductions of Braque's *The Duet* 1937 (fig.61) and *Artist and Model* 1939 were open on Caulfield's easel and these paintings are echoed in his last work. *The Duet*, which is of two people in a room, one playing the piano, the other listening, and *Artist and Model* contain human figures but Caulfield's painting is characteristically unpopulated. The interior depicted in *Braque Curtain* is divided into two halves. To the right the room appears cramped, with the furniture oppressive in stark black and orange and with a brown upright that closes off that half of the painting. A low horizontal beam completes a square space in which a lamp stands. The image of the lamp is doubled with the black form, seemingly a shadow, standing in front of the orange lamp as if about to eclipse it. The atmosphere is almost claustrophobic, as if Caulfield wished to portray his own mortal limitations in the work. The left half of the room is lighter and the space is less constrained. The gloom to the right is alleviated by the rectangular curtain which is made up of warmer creams and yellows as light plays upon it. The pattern on the curtain is directly taken from Braque. *Braque Curtain* could be read as a metaphor for the voyage from life to death, through its rendering of the shift from light to darkness within an artificially constructed interior space. In his only painting of the previous year, *Bishops* 2004, he deals

60
Braque Curtain
2005
Acrylic on canvas
86.5 x 117.3
Tate. Purchased with
assistance from Tate
Members 2010

61

Georges Braque

The Duet

1937

Oil on canvas

131 x 162.5

Musée national d'art

moderne, Centre Georges

Pompidou, Paris

with the play of metaphors in an altogether more direct manner – the doors are slightly ajar, as if someone has just passed through. As Caulfield's final painting, such a reading also reflects on the relationship of the artist to his wife, again making an allusive connection to the manner in which Braque's *The Duet* does not depict two performers but a musician and a listener (albeit one holding a musical score).

Caulfield's ability to animate interior spaces to elicit an atmosphere, to suggest a sense of place shot through with emotional resonance, runs through the majority of his work. With extreme subtlety and finesse, Caulfield explores paradoxes of presence and absence, transience and permanence and the uncanny mix of pleasure and unease encountered in modern life. Caulfield's world presents the muteness of objects but also registers them as signs, icons and metaphors and shows how they serve as catalysts for the feelings that inform our fleeting perceptions. In staging the encounter between objects and the human subject, usually absent from the picture itself but always implied, Caulfield captures the most equivocal, fleeting and fugitive emotions that colour our perceptions and animate our senses. Caulfield was a painter of the unique space and time of our modernity, a painter of modern life: if he felt there was something heroic about quotidian life it was something he shared in his dedication to seeing and enabling us to see it too.

Newport Community
Learning & Libraries

NOTES

FACING THE FUTURE

1 'Patrick Caulfield: A Dialogue with Bryan Robertson', in *Patrick Caulfield*, exh. cat., Hayward Gallery, London 1999, p.30.
2 Keith Patrick, 'Interview with Patrick Caulfield', *Art Line Magazine International*, vol.5 no.8, Summer 1993, p.11.
3 Ibid.
4 Author in conversation with John McEwen, Aug. 2012.
5 Peter Ward, *Patrick Caulfield: Early Years*, Focal Press 2012, pp.20–1.
6 Roger Berthoud, 'Interview with Patrick Caulfield: Where next for Caulfield?', *Times*, 4 Nov. 1981.
7 Lynn Barber, 'Interior Motives: Interview with Patrick Caulfield', *Observer*, 31 Jan. 1999, pp.11–14.
8 Ward 2012, p.21.
9 Barber 1999.
10 Berthoud 1981.
11 Lawrence Gowing, Principal of Chelsea School of Art 1958–65, was an early champion of his work. When Caulfield finished his course at the RCA, Gowing offered him a a part-time teacher post at Chelsea, where he taught from 1963 to 1971.
12 Cyril Connolly, 'On French and English Cultural Relations', *Horizon*, vol.7 no.42, June 1943, p.382.
13 David Sylvester, *Encounter*, Dec. 1954, pp.61–3.
14 Patrick Heron, 'The Americans at the Tate Gallery', *Arts*, vol.30, 6 March 1956, pp.15–16.
15 Caulfield, 'Inspirations', *Royal Academy Quarterly*, Winter 1999.

16 The other two paintings by Hopper were *House by the Railroad* 1925 and *New York Movie* 1939, both Museum of Modern Art, New York.
17 Email from Peter Ward to author, June 2012: 'As far as I can remember, Patrick was attracted by Hopper's treatment of light and shade, the large plain areas in the interior and the frozen time quality of his interiors.'
18 Information from Natalie Gibson, Aug. 2012.
19 Artist in conversation with Edward Lucie-Smith, BBC Radio 3, 2 Nov. 1981.
20 Patrick 1993, pp.9–13.
21 The Indian (Mughal) dagger and scabbard were probably from the Aurangzeb period (1658–1707), Victoria and Albert Museum (IS) 02566.
22 Caulfield quoted in *Chicken Kiev by Candlelight: Patrick Caulfield in Conversation with Bryan Robertson*, Lecon Arts, London 1988–90. ICA 0018466/LA13

THE NEW GENERATION

1 Sarah Jane Checkland, 'An artist with a quixotic eye', *Times*, 31 May 1986.
2 See Prof. Carel Weight, 'Faculty of Fine Art, School of Painting', *RCA Calendar 1958–59* (school's prospectus), pp.43–4. Carel Weight was Professor of Painting, 1957–73.
3 *ARK*, no.1, 1950.
4 Caulfield quoted in *Chicken Kiev by Candlelight* 1988–90.
5 Caulfield, *Aspects*, no.15, Summer 1981.

6 Tom Learner and Jo Crook, *The Impact of Modern Paints*, London 2000.
7 See Harriet Standeven, 'The Appeal of an image: The explosion of commercial paint use among Britain's abstract artists in 1956', *Third Text*, vol.20 no.2, March 2006, pp.251–8.
8 Caulfield quoted in *Chicken Kiev by Candlelight* 1988–90.
9 Caulfield interviewed by Frances Spalding, *Arts Review*, 11 Sept. 1981, p.404.
10 Caulfield interviewed, Nov. 1998, as research for a chapter in Learner and Crook 2000.
11 Lawrence Alloway, *Young Contemporaries*, London 1961, p.3.
12 Anne Seymour, *Marks on Canvas*, exh. cat., Kunstverein Hannover 1969, p.18.
13 Howard Hodgkin, 'Remembering Patrick Caulfield', *The Art Newspaper* no.163, Nov. 2005, p.37.
14 *The New Generation 1964*, exh. cat., Whitechapel Art Gallery, London 1964.

ROMANCE AND IRONY

1 Containing work by 24 artists selected by the artist Richard Hamilton, edition of 40.
2 Chris Prater of Kelpra Studio talking to Pat Gilmour, 6.IV.1976. Transcript made in June 2004. Tate Archive, TAV 51AB.
3 'Lithographs and Original Prints: Why do artists make prints? Answers by printmakers to questions put by Mark Glazebrook',

Studio International, supplement, June 1967, p.3.

4 Jules Laforgue, *Some Poems by Jules Laforgue*, book and 22 screenprints in colour with a separate suite of six prints, each signed and numbered in grey leatherette covered box, edition of 200, Petersburg Press in association with Waddington Galleries, London, 1973.

5 Caulfield quoted in *Chicken Kiev by Candlelight*, 1988–90.

6 Caulfield quoted in *National Life Stories: Artists' Lives: Patrick Caulfield*, BL Ref C46614, 1996–8.

7 Mel Gooding, 'Patrick Caulfield: The Prints' in *Patrick Caulfield: The Complete Prints 1964–1999*, Alan Cristea Gallery, London 1999, p.8.

8 Juan Gris, *Bulletin de la Vie Artistique*, Paris 1925.

9 Caulfield quoted in *National Life Stories*, 1996–8.

10 Caulfield, 'Inspirations', 1999.

11 J. Charles Fox and Charles Bradley Ford, *The Parish Churches of England*, London 1954.

12 *Patrick Caulfield*, 1999, p.25.

13 Caulfield, letter, 18 June 1970, in *The Tate Gallery 1968–70*, London 1970.

MODERN LIFE

1 Charles Baudelaire, 'The Painter of Modern Life' (1859) in *Charles Baudelaire: Selected Writings on Art and Artists*, ed. P.E. Charvet, London 1981, p.420.

2 Charles Baudelaire, 'The Heroism of Modern Life' (1846) in *Charles*

Baudelaire 1981, p.104.

3 Charles Baudelaire, *Intimate Journals*, trans. Christopher Isherwood, London 1949, section 16.

4 Ibid., section 16.

5 Baudelaire's melancholy is more savage: *spleen* is a keyword in his poetry and can be defined as a melancholy tinged with disgust. Caulfield's melancholy lacks this sense of revulsion but it is equally real and important.

6 Caulfield quoted in Marco Livingstone, *Patrick Caulfield: Paintings 1963–81*, exh. cat., Walker Art Gallery, Liverpool, and Tate Gallery, and London 1981, p.25.

7 Copied from a photograph of the concrete villa at Brunn, Czechoslovakia, designed by O. Stary, repr. in C.G. Holme, *Decorative Art: The Studio Year Book*, London 1932, p.131

8 Caulfield quoted in Marco Livingstone, *Patrick Caulfield Paintings*, London 2005, p.52.

9 See T.J. Clark, *The Painting of Modern Life: Paris in the Art of Manet and His Followers*, Princeton 1999.

10 See Hal Foster, *The First Pop Age: Painting and Subjectivity in the Art of Hamilton, Lichtenstein, Warhol, Richter and Ruscha*, Princeton 2012.

11 Colin Finch, *Image as Language: Aspects of British Art 1950–1968*, Harmondsworth 1969, p.19.

12 Caulfield quoted in *National Life Stories*, 1996–8.

13 *Decorative Art in Modern Interiors*, vol.59, 1969–70 and

Olga Stier, *Continental Interiors for Small Flats*, London 1969.

14 Caulfield quoted in *National Life Stories*, 1996–8.

15 'Week-End Houses and Cottages' in Holme 1932, p.111.

16 Christopher Finch, 'The Paintings of Patrick Caulfield', *Art International*, vol.10, Jan. 1966, pp.47–9.

17 Livingstone 2005, p.71.

18 Norbert Lynton, *Patrick Caulfield: Painting and Prints*, exh. cat., Scottish Arts Council Gallery, Edinburgh 1975.

19 Caulfield quoted in *Chicken Kiev by Candlelight*, 1988–90.

CHICKEN KIEV BY CANDLELIGHT

1 Caulfield quoted in *Chicken Kiev by Candlelight*, 1988–90.

2 Caulfield quoted in Livingstone 2005, p.101.

3 Ibid., p.104.

4 Ibid.

5 Caulfield quoted in Livingstone 1981, p.28.

THE FRIENDSHIP OF HOTEL ROOMS

1 Caulfield, 'Inspirations', 1999.

2 Caulfield got the title from the name of a horse that ran in the 1994 Grand National. It was also the advertising slogan for Rust-oleum paints.

3 John McEwen, *The Artist's Eye: Patrick Caulfield*, exh. cat., The National Gallery, London 1986, p.9.

4 Ibid., pp.9–10.

5 Ibid., p.12.

6 Ibid.

7 For a detailed analysis of Caulfield's use of sketchbook

drawings see Sarah Whitfield, 'Patrick Caulfield: Sketchbook drawings for Still Life: Spring Fashion', *The Burlington Magazine*, vol.148, March 2006, pp.203–5.
8 Caulfield quoted in *National Life Stories*, 1996–8.

LIGHT AND SHADE
1 Charles Sterling, *Still Life Painting from Antiquity to the Present Time*, New York 1959.
2 Caulfield quoted in Livingstone 1981, p.30.
3 Caulfield quoted in William Feaver, 'Obituary: Patrick Caulfield', *Guardian*, 3 Oct. 2005.
4 Ibid.

PHOTOGRAPHIC CREDITS
Images are courtesy the owner of the work unless otherwise stated.
Private collection/The Bridgeman Art Library 15
© The British Library Board 56
Courtesy Christie's 5
Photo: Paulo Costa 13
Courtesy Alan Cristea Gallery 18
Prudence Cuming Associates Ltd 31
Photo: Tom Lucas 34
Photo: Tore H. Røyneland 21
© Centre Pompidou, MNAM-CCI, Dist. RMN-Grand Palais / Droits réservés 61
© 2012. Photo The Philadelphia Museum of Art/Art Resource/Scala, Florence 23
Courtesy of Sotheby's 12 38
Tate Photography/David Lambert 55
Tate Photography/David Lambert & Rod Tidnam 36, 37, 41, 42
Courtesy Waddington Custot Galleries, London.
 Photography Prudence Cuming Associates Ltd, London 17,
30, 49, 50, 53, 54, 59
Photography Katherine Wetzel 43

COPYRIGHT CREDITS

ACKNOWLEDGEMENTS
This book is published on the occasion of *Patrick Caulfield*, Tate Britain, 5 June – 1 September 2013. I am grateful to all the individuals and institutions that have so generously supported this project. This exhibition has been made possible by the provision of insurance through the Government Indemnity Scheme. Tate Britain would like to thank HM Government for providing Government Indemnity and the Department for Culture, Media and Sport and Arts Council England for arranging the indemnity www.tate.org.uk/Caulfield

In the course of writing this book many people have helped me and deserve thanks but I am particularly indebted to Janet Nathan, Patrick Caulfield's widow, for her continual encouragement and support. I would also like to acknowledge the help of Richard Riley who generously shared his knowledge and understanding of Caulfield's work. I have benefited enormously from conversations with colleagues and friends and I would like to mention in particular Melissa Blanchflower and Andrew Wilson. I am very grateful to them.

I would also like to convey my thanks to Luke Caulfield, Pauline Caulfield, Alan Cristea, Penelope Curtis, Sarah den Dikken, Diana Eccles, Ann Gallagher, Natalie Gibson, Howard Hodgkin, Gary Hume, Martin Jenkins, Simon Ling, Clare Preston, Simon Martin, Susan May, Mick Moon, Felix Mottram, John McEwen, Amy Pettifer, Livia Rolandini, Nicholas Serota, Reka Szili, Leslie Waddington, Peter Ward, the staff at Tate Publishing especially Alice Chasey, Roanne Marner, Deborah Metherell and Beth Thomas.

Special thanks to my family.

INDEX